This book is dedicated to all those who were touched by the devastating hurricanes that ravaged the South in 2005, and to the innumerable others whose unwavering support both in the immediate aftermath and well after the storm clouds lifted continues to this day.

Published in Nashville, Tennessee by NAKED INK™ of the General Trade Book Group of Thomas Nelson Publishers, Inc. Please visit us at www.nakedink.net.

NAKED INK™ books may be purchased in bulk for educational, business, fundraising, or sales promotional use. For more information please e-mail SpecialMarkets@ThomasNelson.com.

The American Red Cross name and emblem are used with its permission, which in no way constitutes an endorsement, express or implied, of any product, service, company or individual.

The Habitat for Humanity name and emblem are used with the permission of Habitat for Humanity International, Inc., which in no way constitutes an endorsement, express or implied, of any product, service, company or individual.

Library of Congress cataloguing-in-publication data on file with the Library of Congress.

ISBN-10: 1-5955-5857-8
ISBN-13: 978-1-5955-5857-2

Printed in the United States of America

06 07 08 09 10 – 5 4 3 2 1

Love Letters to the South

Messages of Hope and Healing from the World's Best-Loved Celebritites

NAKED INK

EDITOR'S NOTE

With surreal images of the desolate South capturing the world's attention, and within days of Katrina's ripping through the glorious United States, my friend and renowned photographer Paul Alexander agreed to donate his time and resources and begin capturing portraits of some of the world's most recognizable faces. The goal was to find a charitable initiative that would allow us, in our own small way, be part of the efforts to assist in the relief and rebuilding. Within hours, a photo studio was set up at the Windsor Arms Hotel in Toronto and the outreach efforts began to the Hollywood community. The response overwhelmed us. Within days, we had the support of some of Hollywood's biggest stars, and it seemed that everyone wanted to help in some way. Love Letters to the South was born.

For the next eight months, Paul continued to make this project a priority, and turned away numerous opportunities while he spent days and nights agonizing over the perfect images to match the heartfelt love letters. His art direction is second to none, and this endeavour became a labour of love for him and me. I will always be tremendously grateful to Paul, for his wisdom, creativity, commitment and friendship.

Without hesitation and after only a single phone conversation, David Dunham of Thomas Nelson Publishers and Rebekah Whitlock of NAKED INK agreed to publish this book in support of The American Red Cross' Disaster Relief Fund and Habitat for Humanity's Operation Home Delivery - two organizations whose unyielding commitment to immediate assistance and long-term rebuilding wherever disaster occurs is paramount. Both Rebekah and David are visionaries – they understood the concept prior to my completing the pitch, and their advocacy for this book is truly admirable. I owe the most sincere gratitude to them both.

Ensuring that people knew about this project was no small task. PJ Tarasuk and Stephanie Erb spent incalculable hours contacting the entertainment community and rallying support. Natalie Brown, Cheryl Williams, Keith McLean and Bhargavi Mungamuru were important members of PJ's team, and I offer my sincere appreciation for all their hard work and dedication.

Countless people went above and beyond when asked to champion the project, and the many publicists, managers, agents and celebrities themselves who immediately answered the call deserve thanks. The pages of this book are filled with photos of many people who have personal connections to Mississippi, Louisiana, Texas and Florida, and we were regaled with their personal stories. Many celebrities contacted us personally and asked to participate – either because they were from the South, or had spent time in the South volunteering with Habitat for Humanity and The American Red Cross. It is with the utmost respect, admiration and appreciation that I acknowledge them.

There were many, many people whose kind assistance allowed us to complete this project, and whom we do not have enough praise for. In particular, Henry Kim, whose steadfast devotion motivated us, encouraged us, and provided friendship from the moment we met him.

Ryan Priest opened his doors – literally day and night – designed the cover, and put the final layouts in place. He is a wonderful guy, and this book would not have been the same without him.

Cliff Hoppus, stylist extraordinaire was invaluable, and not only ensured that the subjects looked great, but always made us feel important with a kind word and smile.

Special thanks goes to Liam Greenlaw and the Snudge Bros. for their design and layout expertise, Gus Mouskos of Who's Your Printer, for the rapid turn around of our critical proofs, Meghan Janushewski, Jay Harasym, Jason Groves and Cherlyne Knox - wonderful people whose creative contributions are significant. My indispensable right hand Roanne Goldsman provided levity during the most stressful days, Stephen Shinn jumped in head first when asked, and each member of my phenomenal team at Aerial Communications Group deserve wholehearted thanks.

Over the course of this endeavour, many other photographers offered to collaborate, and special mention goes to Clio Bitboul for reaching out to Alison Dyer, Nabil and Michael Grecco. I am grateful to them for giving their time, and sharing their art with us.

Donna Karan, Kristin Kavanagh and Brooke Mazzella at DKNY Jeans are champions of this project, and embody the "keep helping" theme.

I would be remiss in not mentioning Anastasia Saradoc at EMI, Shelly Hancock at MAC, Jennifer Pinto at Exclusive Artists, and the team at The Artist Group in Toronto. Our friends at Accor Hotels, in particular Stephanie Versin and Craig Cunningham, the incomparable Brent Smith and Gregory Maliassas at Sofitel Los Angeles and the exceptional Jennifer Tsonas, Erik Anderouard, Vincent Vienne, and Teresa Duncker at Sofitel New York – many thanks for the spectacular shooting locations and kind assistance. George Friedmann at the Windsor Arms in Toronto, and Manya DuHoffman at the Roosevelt, thank you.

Muhammad Ali is quoted as saying "service to others is the rent you pay for your room here on Earth." Anna Masters, Scott Umstaddt and Jonathan Reckford at Habitat for Humanity, and Laura Davis and Julie Whitmer at The American Red Cross are extraordinary champions of the importance of service. You are all an inspiration, and your guidance and help is so valued.

Lastly, special thanks go to my parents, Dr. Emanuel and Leny Tward, who always taught my brothers and me to live our lives with compassion and to use our talents to advance humanity. It is true that life's greatest rewards are those that are shared with family, and my reward is being able to share this adventure with my husband Henry and children, Arielle and Oliver who are my greatest pride.

In the same way that no one could have predicted the devastation that the hurricanes of 2005 caused or the remarkable outpouring of support in its aftermath, I could not have predicted the number of extraordinary men and women of conscience who lent a helping hand. Thank you, thank you all.

Naomi Strasser

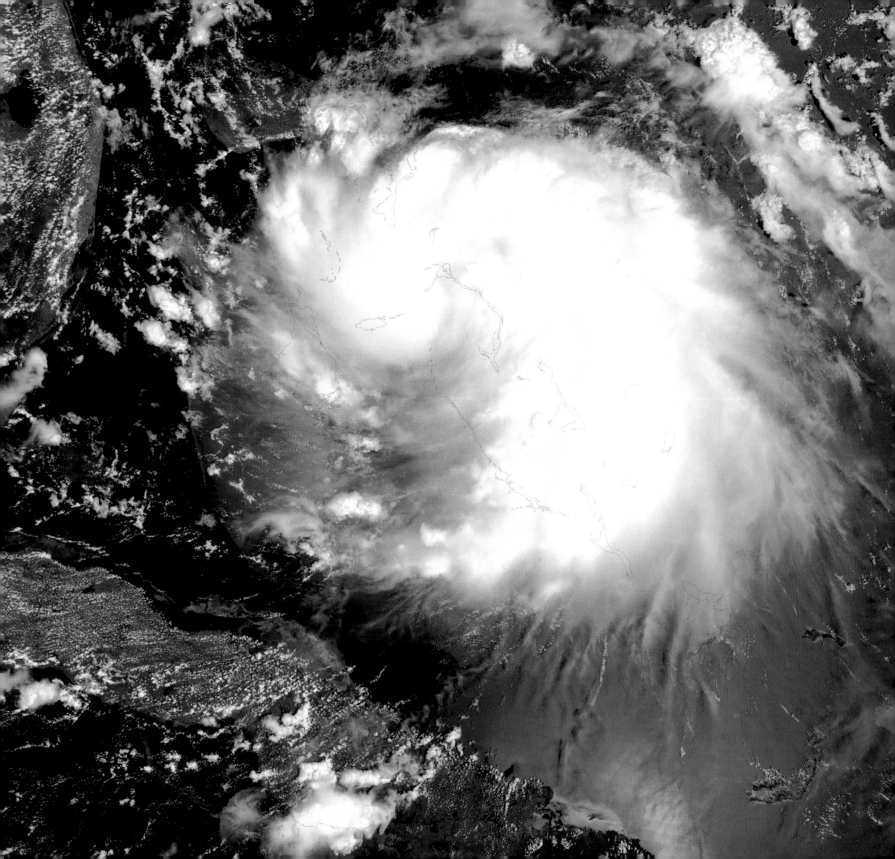

Hurricane Katrina

In late August, Katrina became the 11th named storm of the turbulent 2005 Atlantic hurricane season and its most deadly and destructive.

At midnight ET, August 28th Katrina was centered 90 miles south of the Mississippi River, it was moving to the north west at 10mph.

As far east as Mobile Alabama, 118 miles away from New Orleans, authorities warned of storm surges approaching 20 feet.

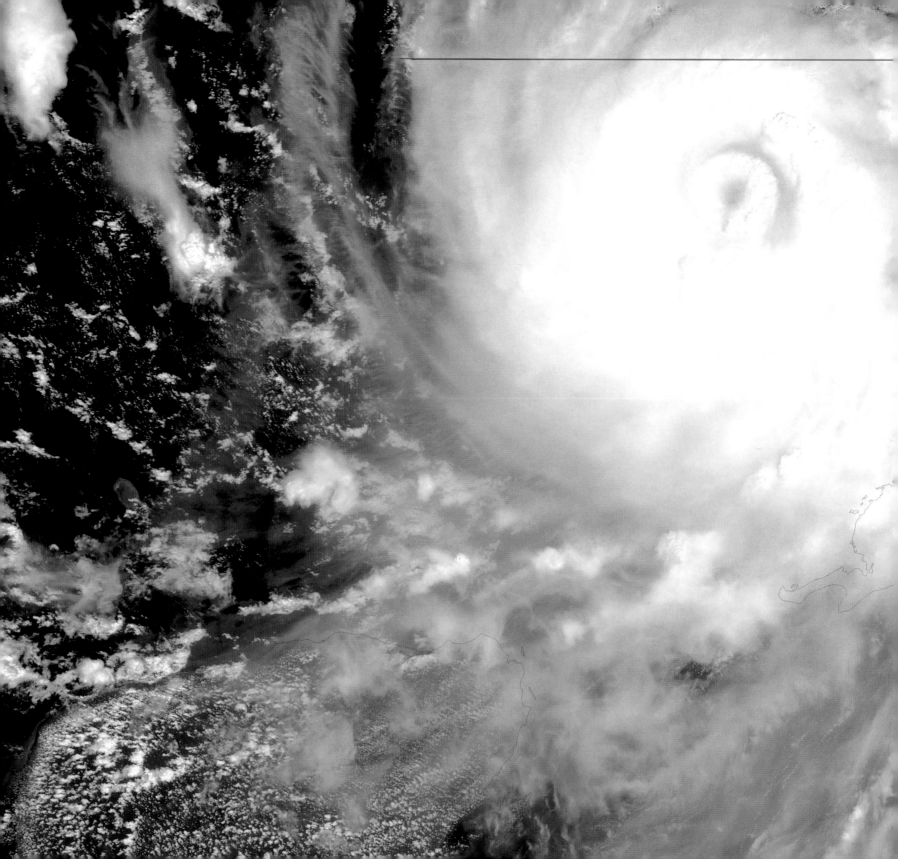

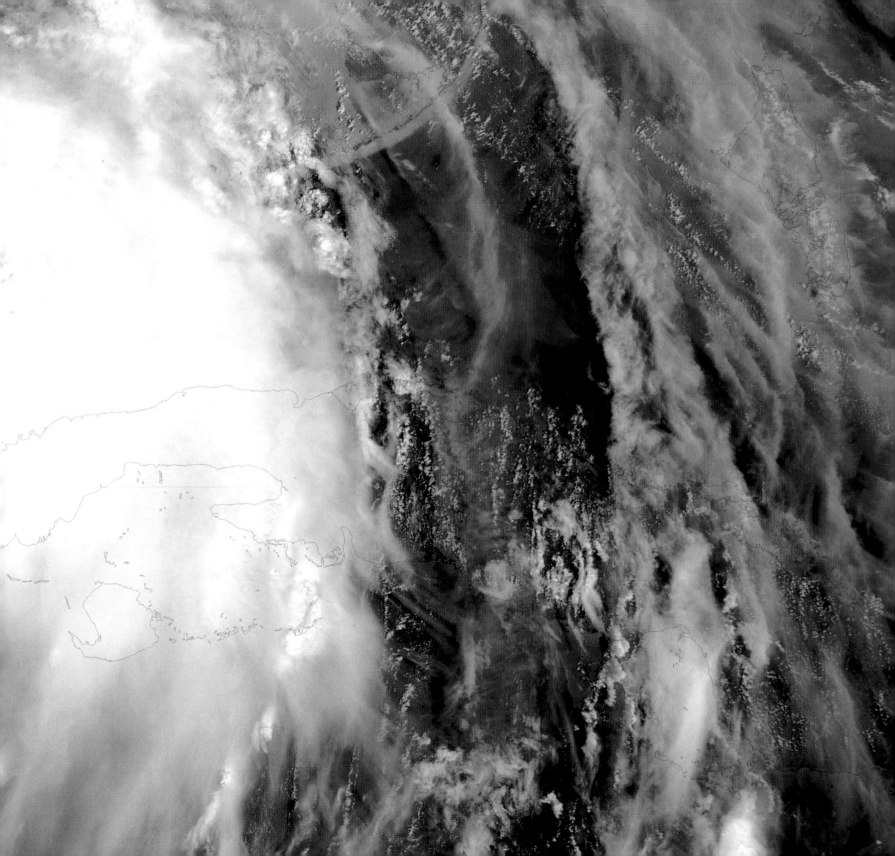

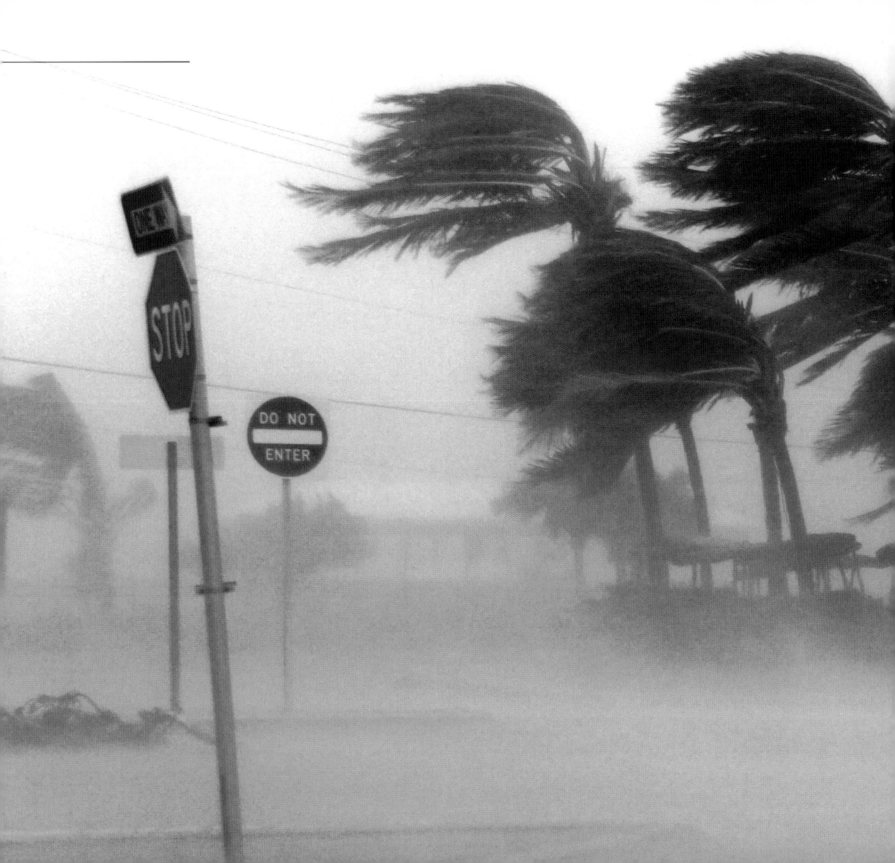

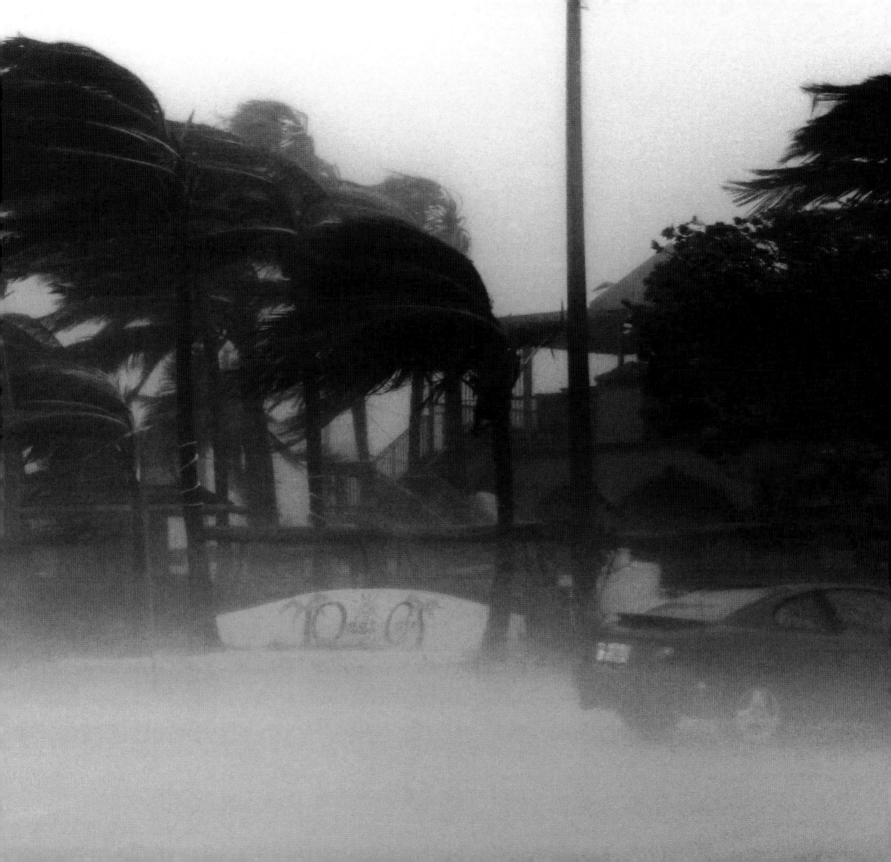

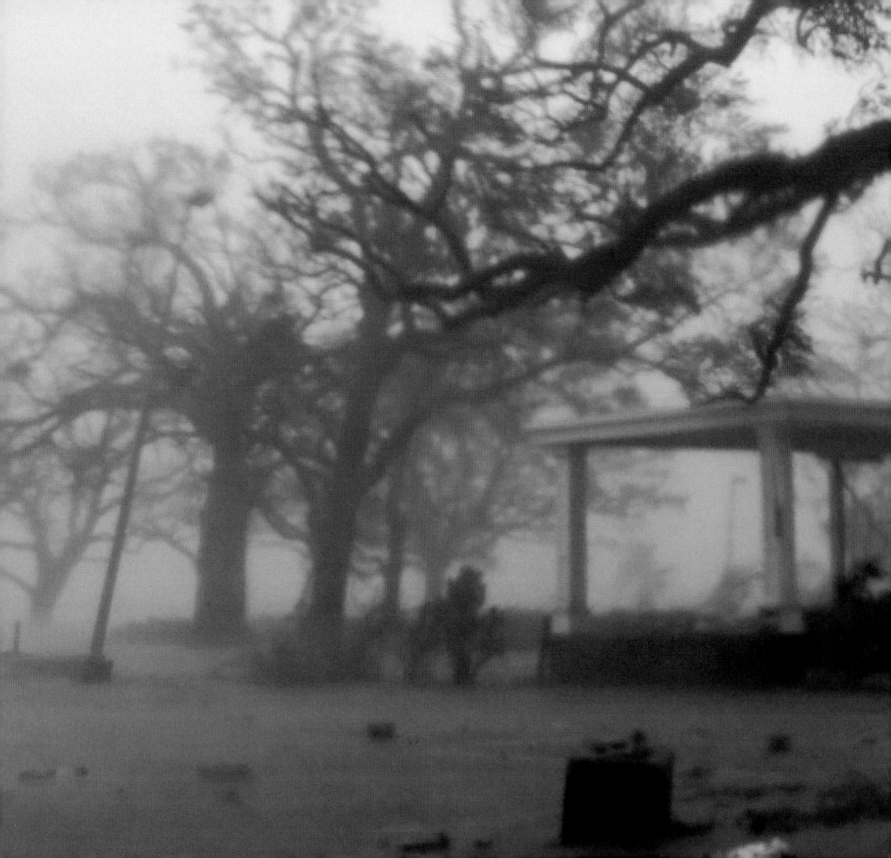

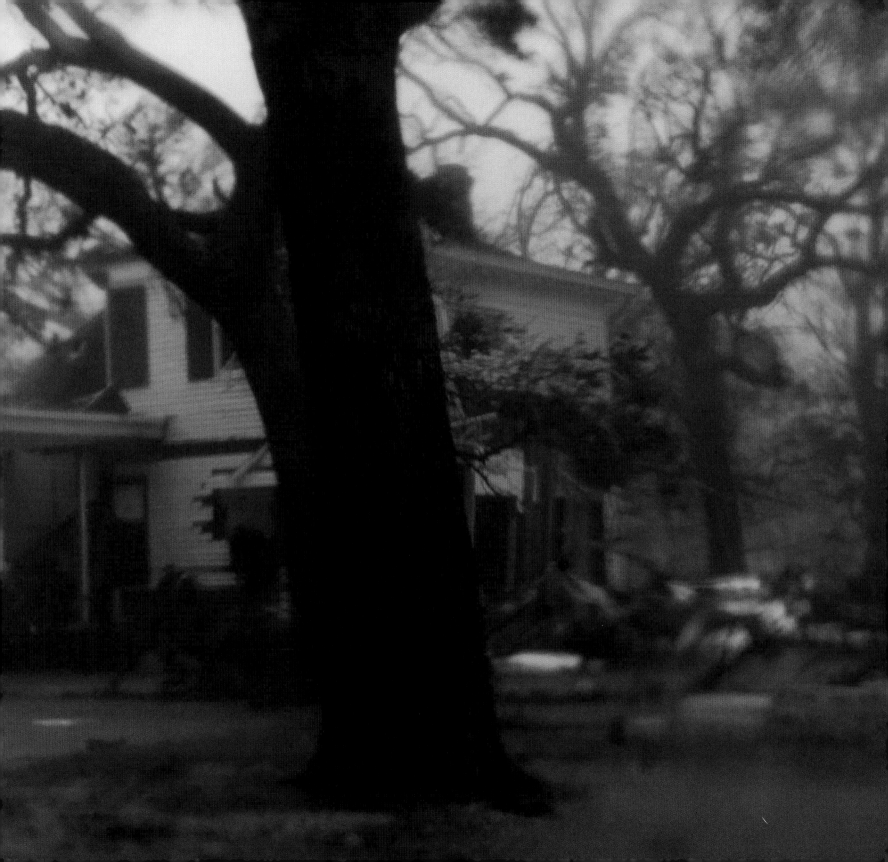

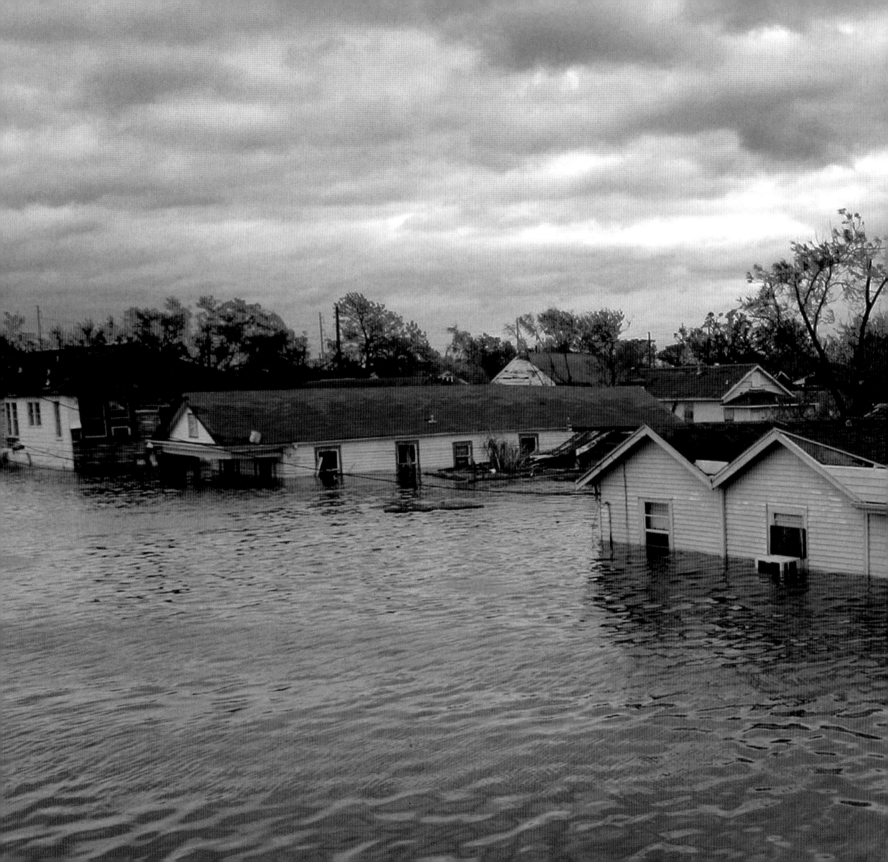

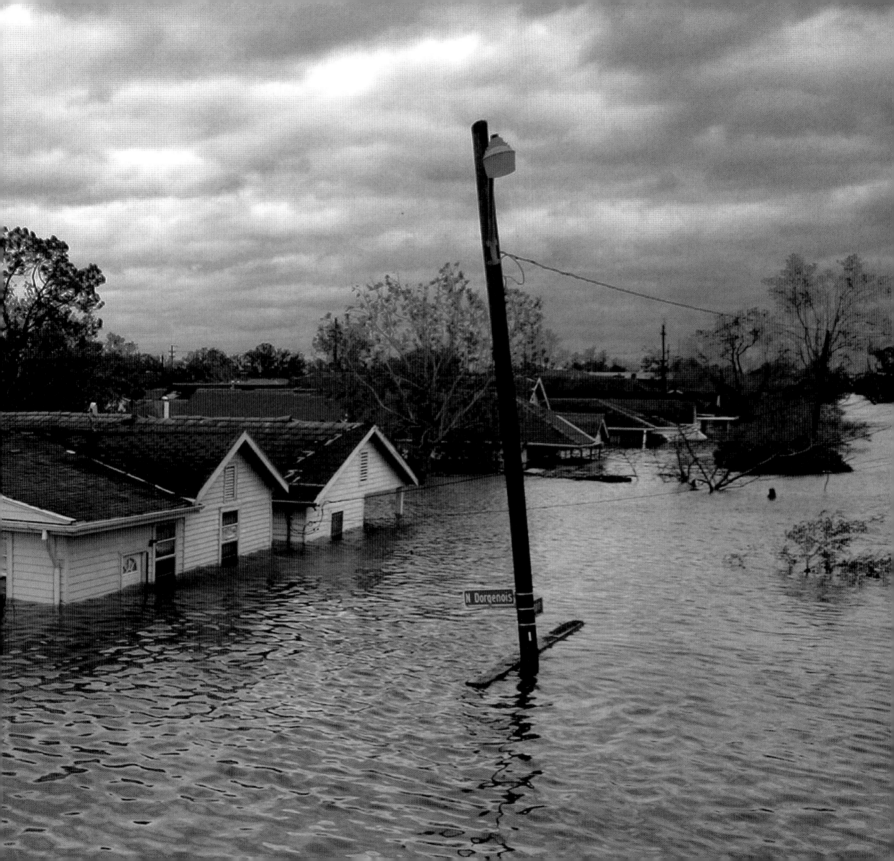

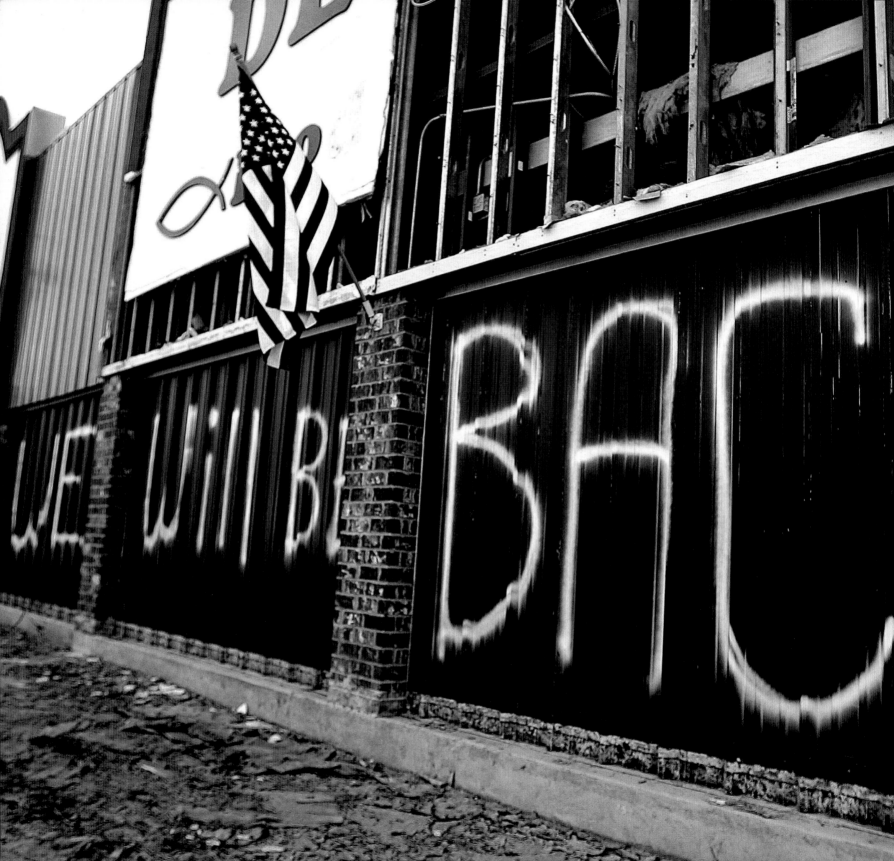

HeLp.

and keep HeLping.

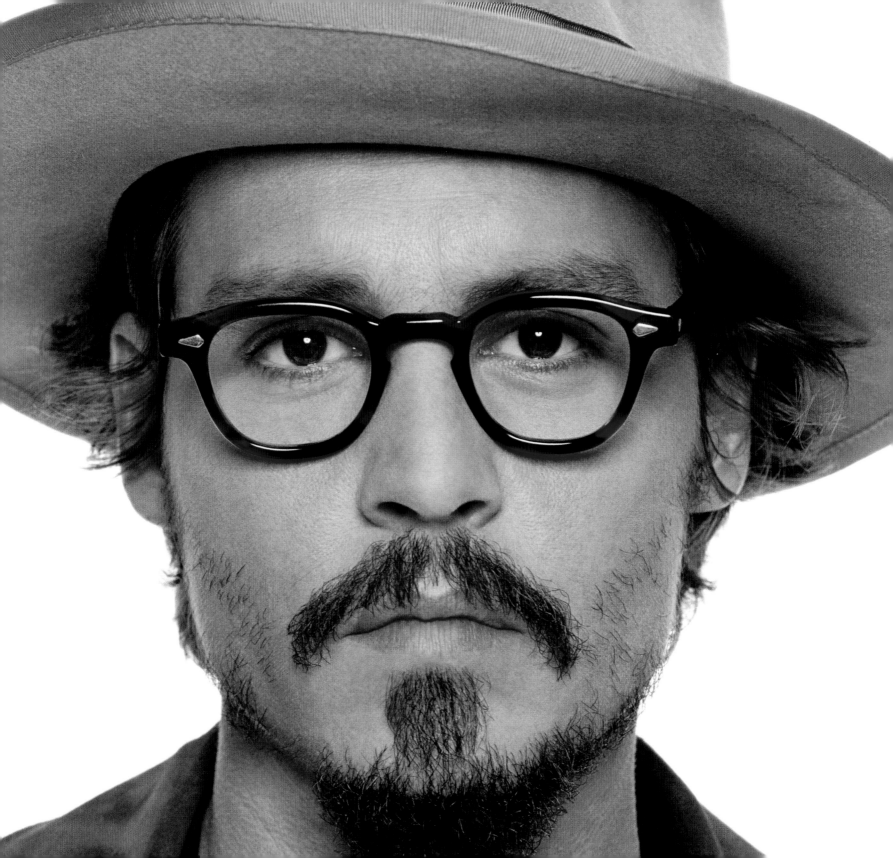

We are all with you.

Courage,

[signature]

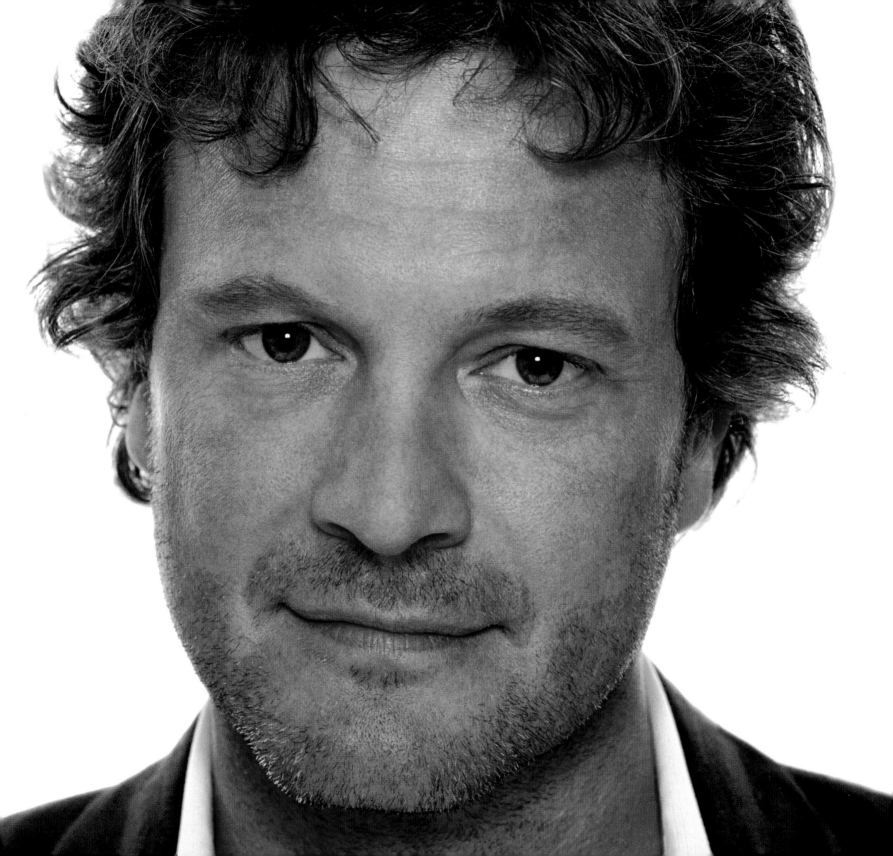

As a gal from where the
"wheat is sweet,"
I stand next to you, for you.
 As your neighbor, friend, and
Sister. You have my prayers,
 my heart, my SONG.

Kristi
Chenoweth

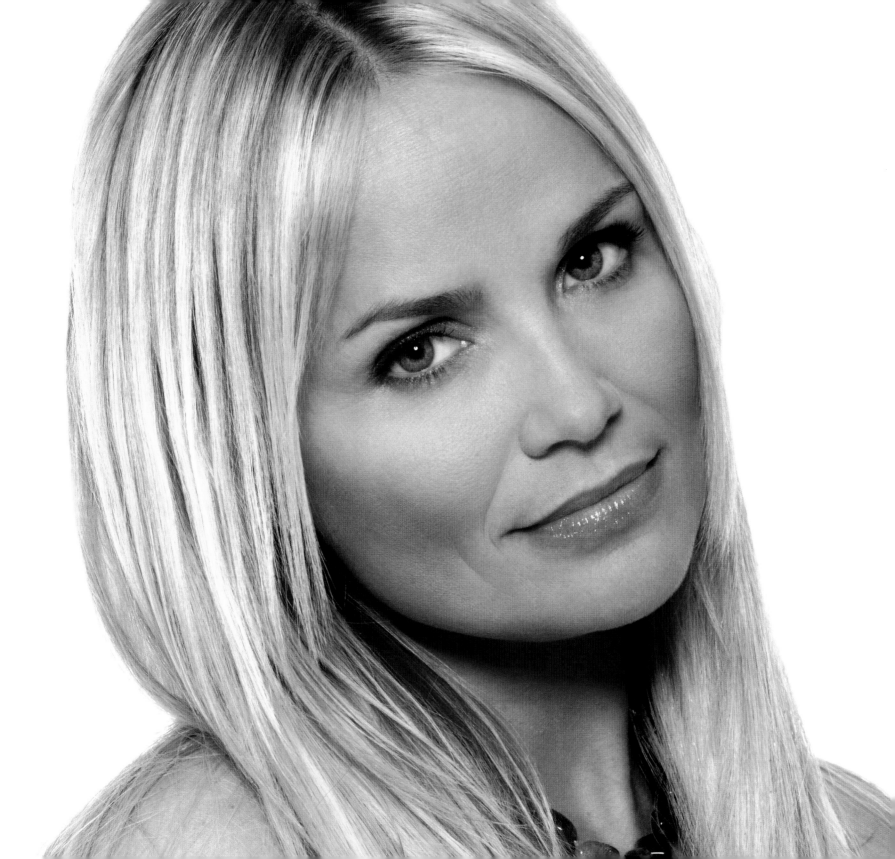

I'M SURE THERE IS VERY LITTLE THAT I
CAN DO OR SAY TO REINFUSE YOU WITH HOPE.
BUT, I CAN SAY THAT I HAVE HOPE.
BECAUSE PEOPLE HAVEN'T STOPPED WATCHING.
PEOPLE HAVEN'T STOPPED TALKING,
PEOPLE HAVEN'T STOPPED THINKING ABOUT YOU.
THEY WON'T FORGET.

PEOPLE, MILLIONS OF PEOPLE ARE WAITING
FOR DECISIONS TO BE MADE
I THINK THE DECISION MAKERS FEEL THIS PRESSURE
I HOPE THE RIGHT THING WILL BE DONE.
KEEP FIGHTING.
WE'RE WITH YOU.

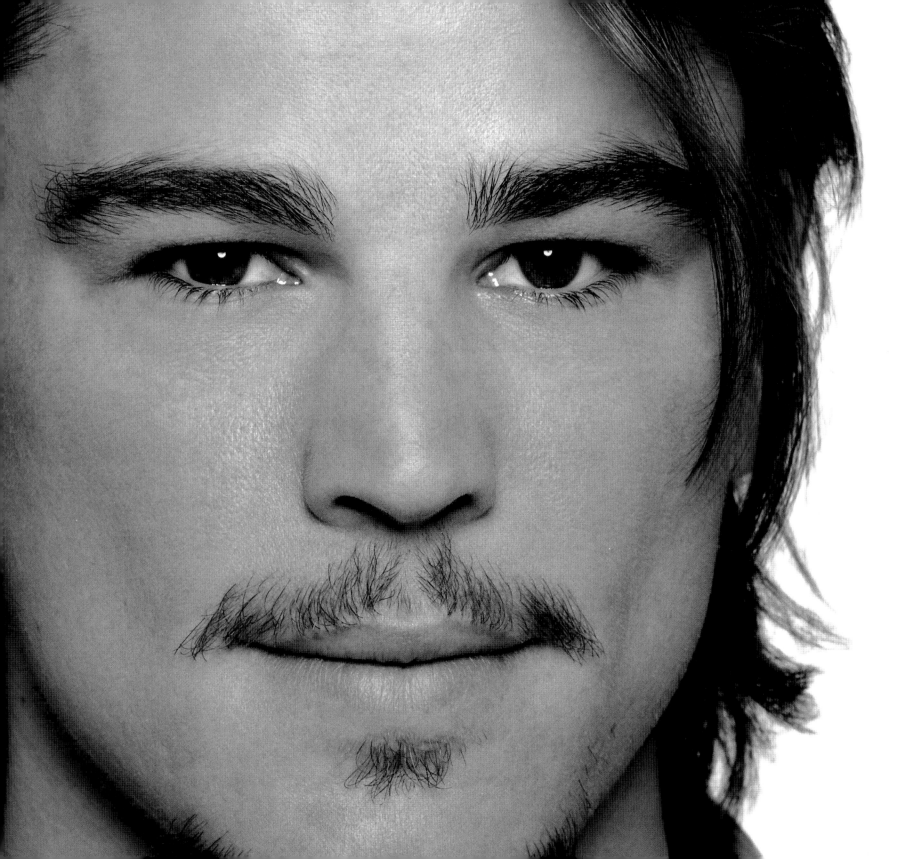

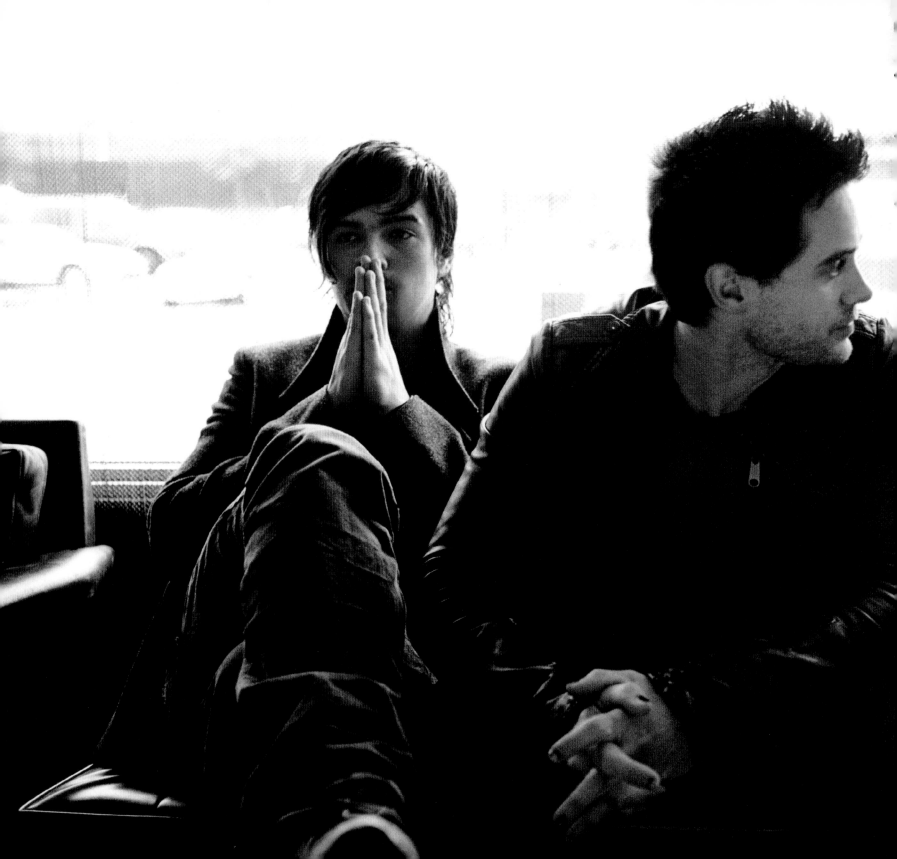

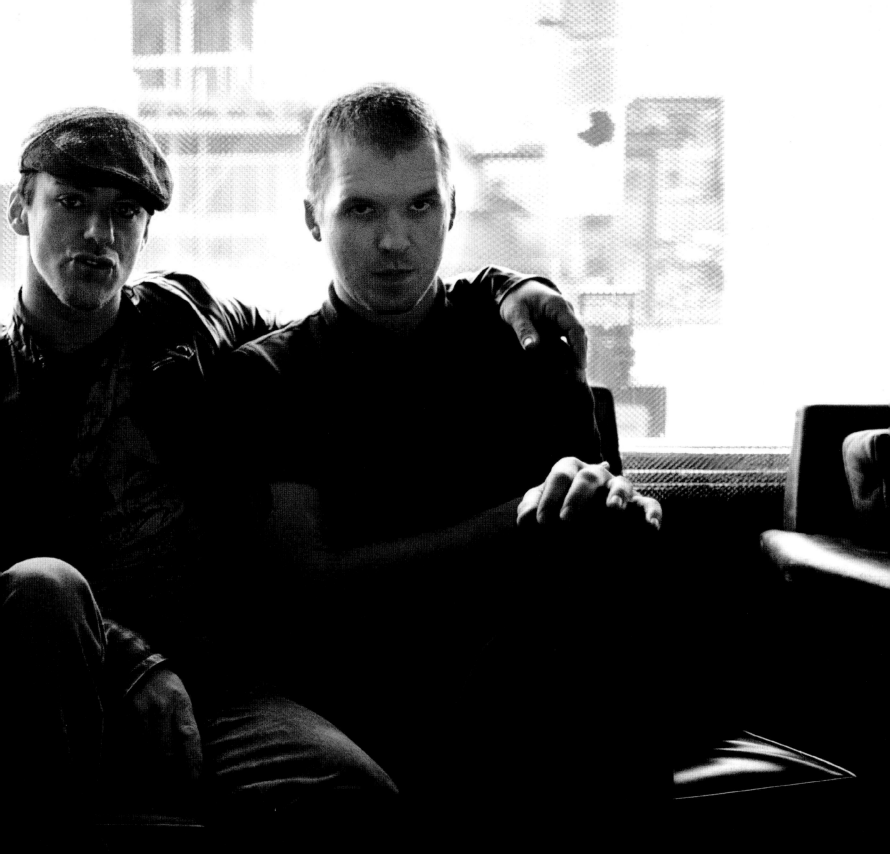

To everybody in the
Dirtay "Ana" I think
of you often & love you
all your Spirits
Will rise & your
Souls Will sing
again Sha

Clifton
Collier Jr.

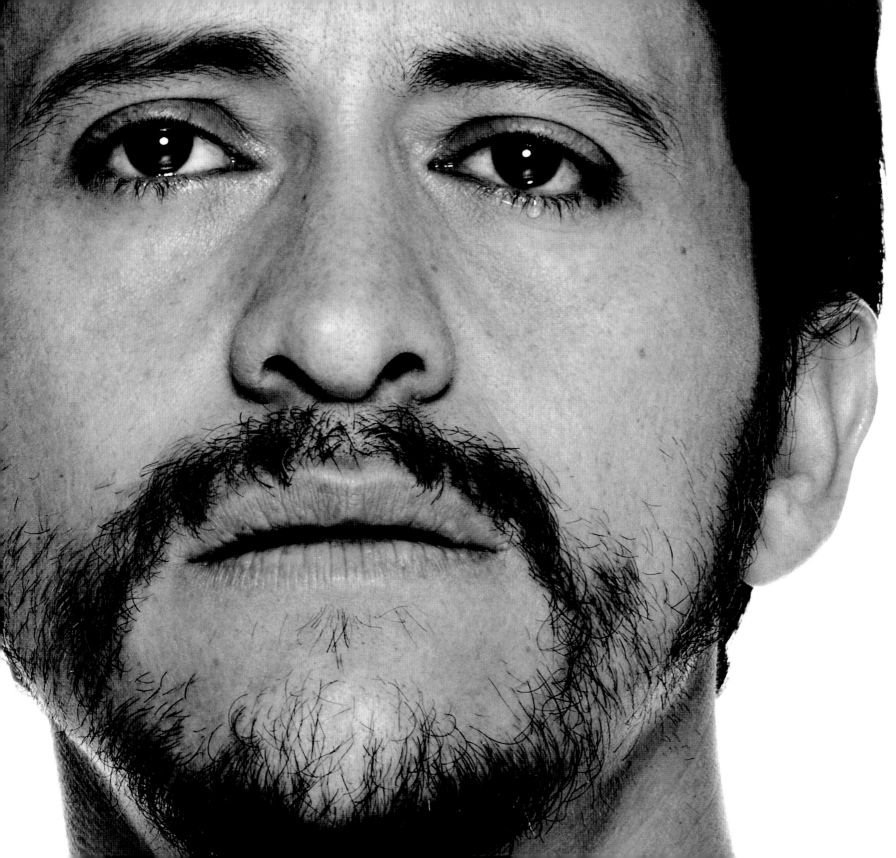

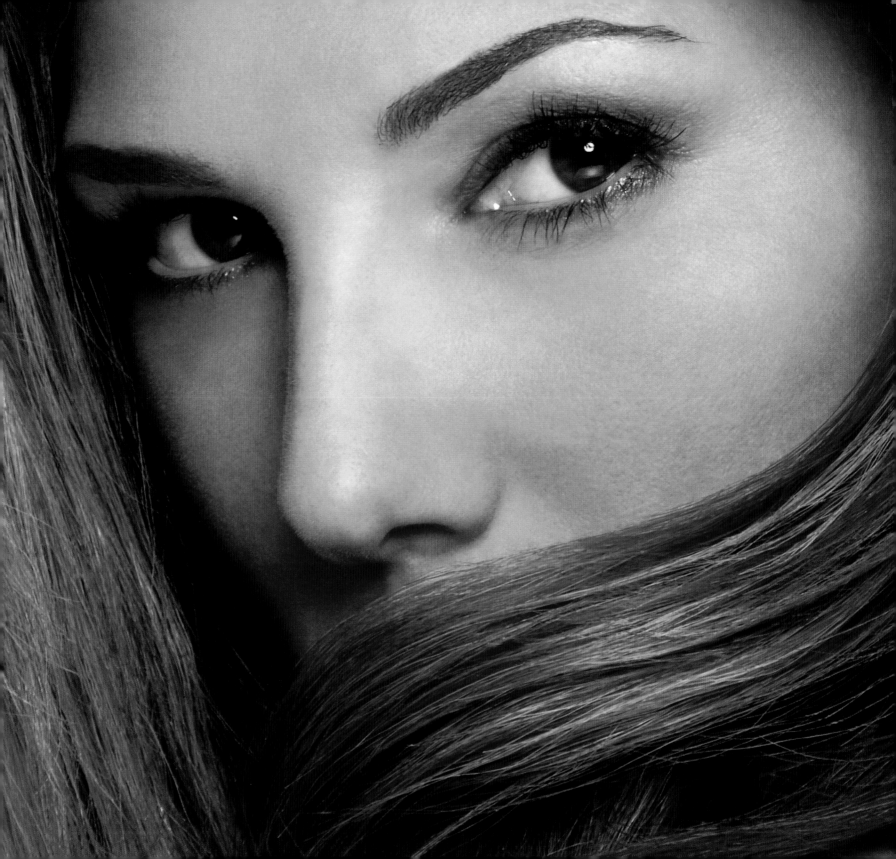

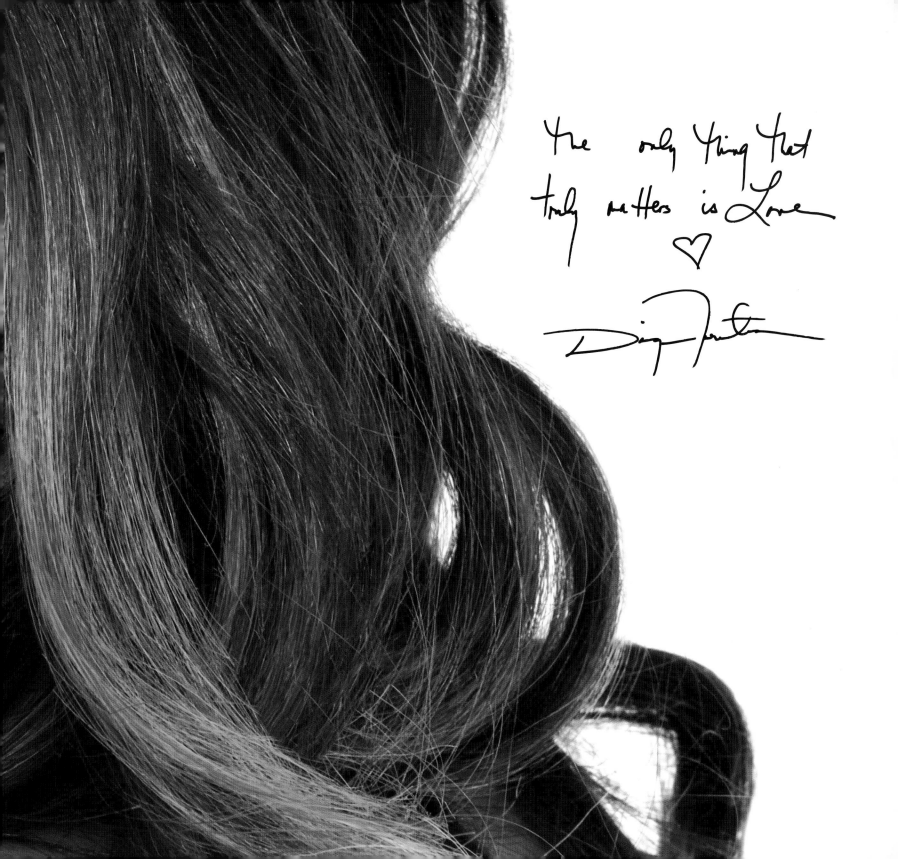

Every living being
deserves enough to LIVE.
Please help
love
Claire O'olan

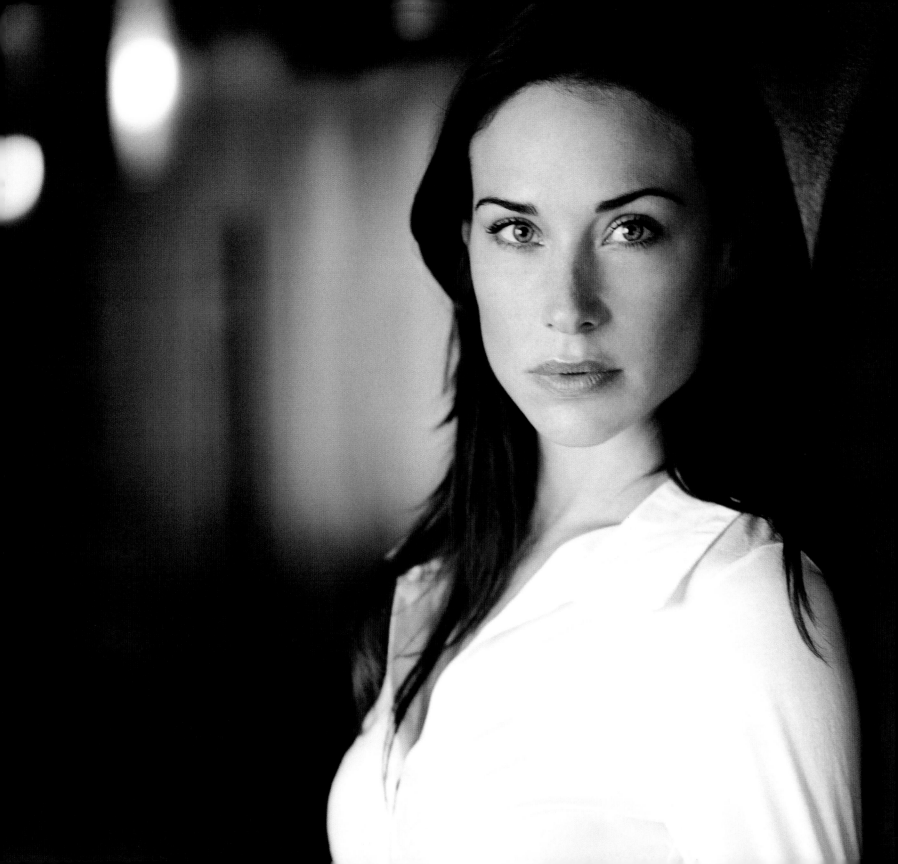

Our thoughts and prayers
are with all of you...
every day.
Stay strong and clear.
We will all soon dance
our way back to
Dixieland.

Love,

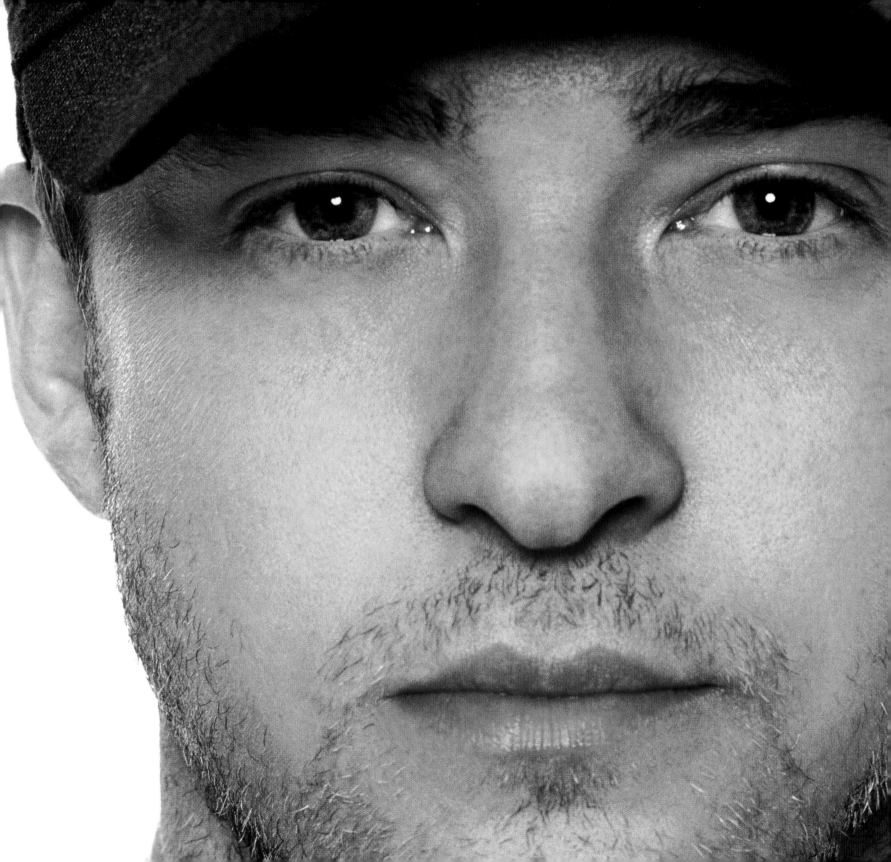

Hope Faith
Love

Are More Powerful
than any Hurricane
But the greatest of these
is Love...
Walls May Crumble
Buildings May Fall
But Love Endures

Natasha
Hurlson

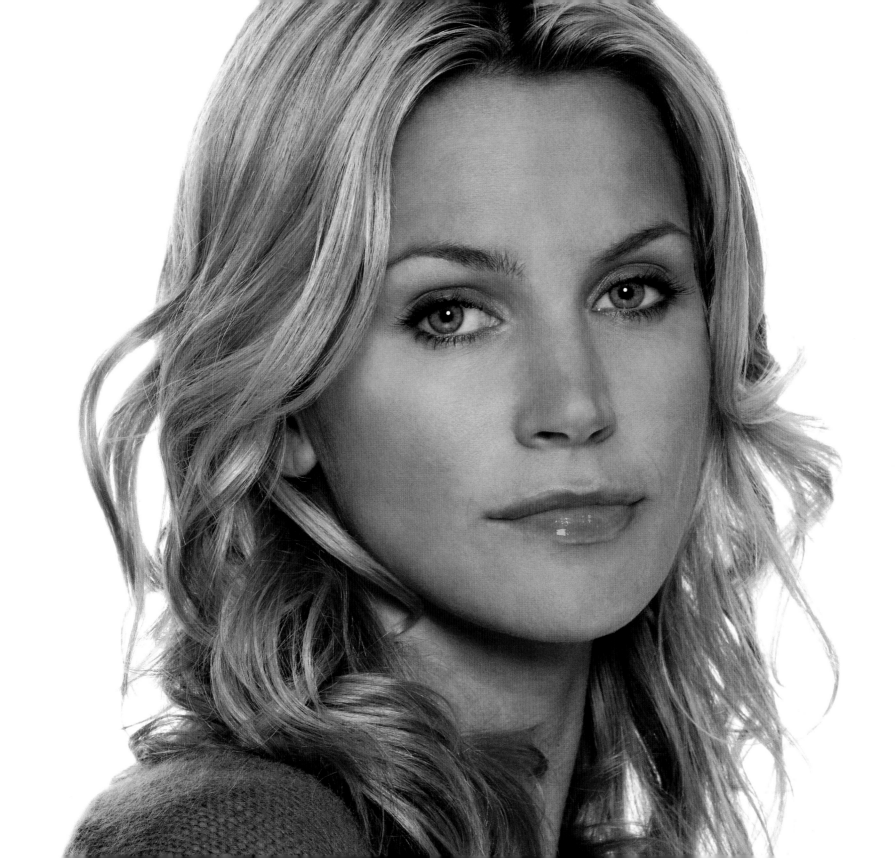

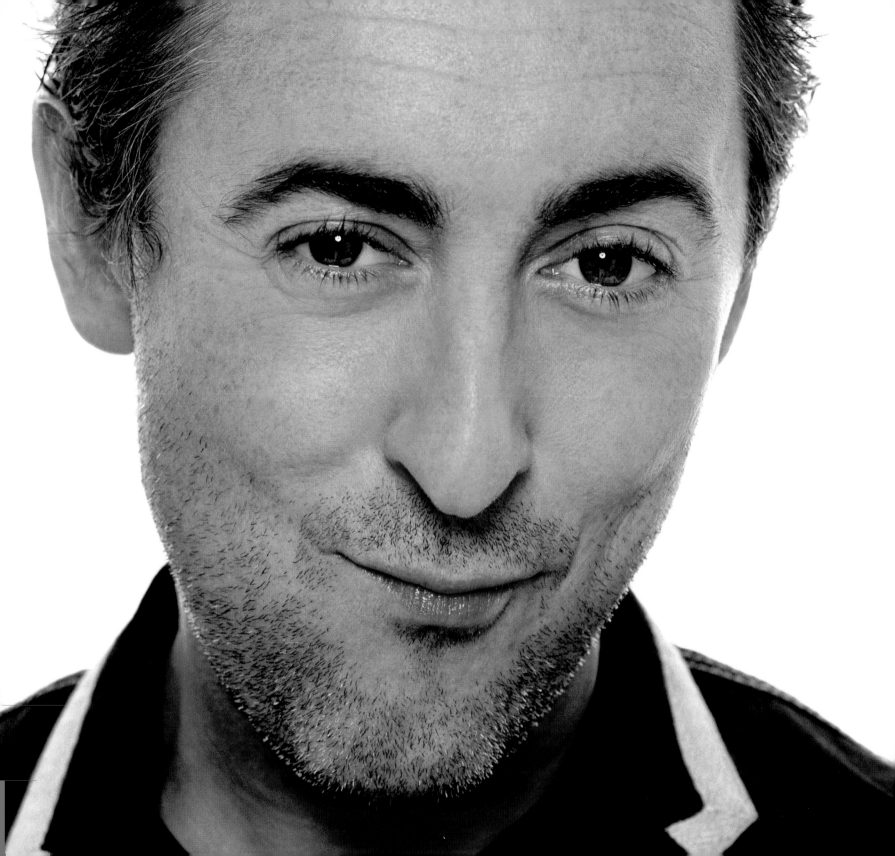

EQUALITY
RESPECT
FOR
EVERYONE
ALWAYS!

Alan Cumming.

No amount of water can drown
the music of New Orleans —
its spirit, its soul; its people will
sing again, I have no doubt . .
Until then let the homeless find
some shelter in the hearts of others —
I send you mine.

Love & more,

Helena Bonham Carter

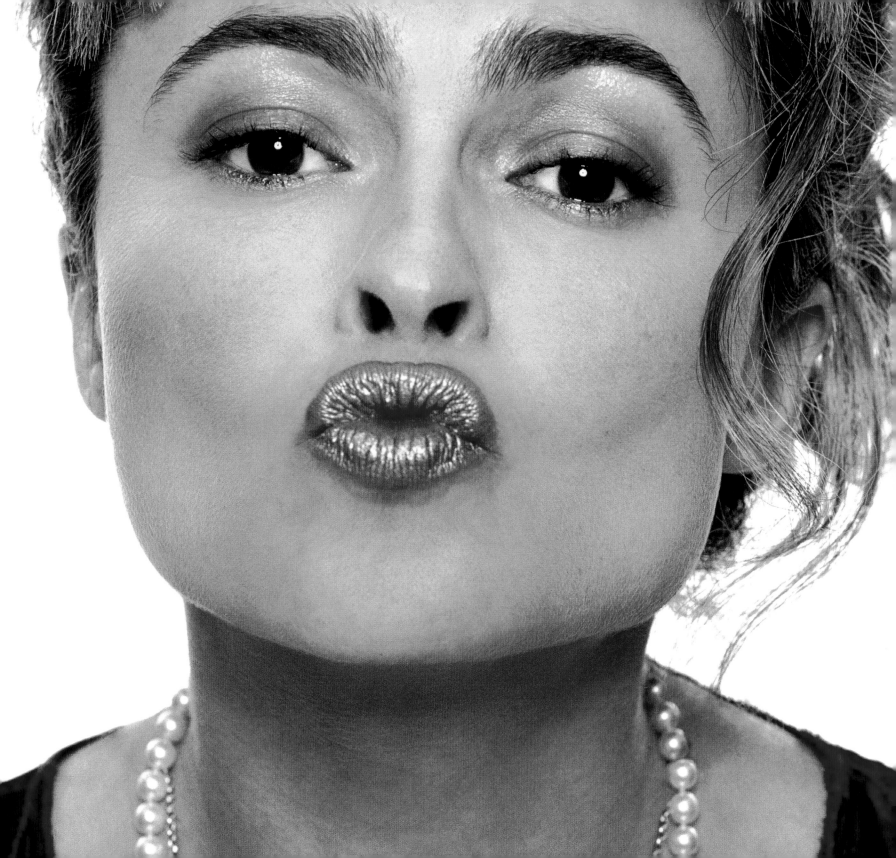

It looked like..... thousands of
MATCHSTICKS strewn ACRoss the ground.
It was people's homes......
 Lives, MEMORIES.
The images WERE haunting.
So MANY TEARS Shed......
The WATER CANNOT wipe them AWAY.
And yet there is hope.
There is PRAYER.
WE must not Forget.....

RE-NEW ORLEANS!

Bring LA. Miss. BACK.... To the great
Ladies they once WERE!!

Jimmy Smits

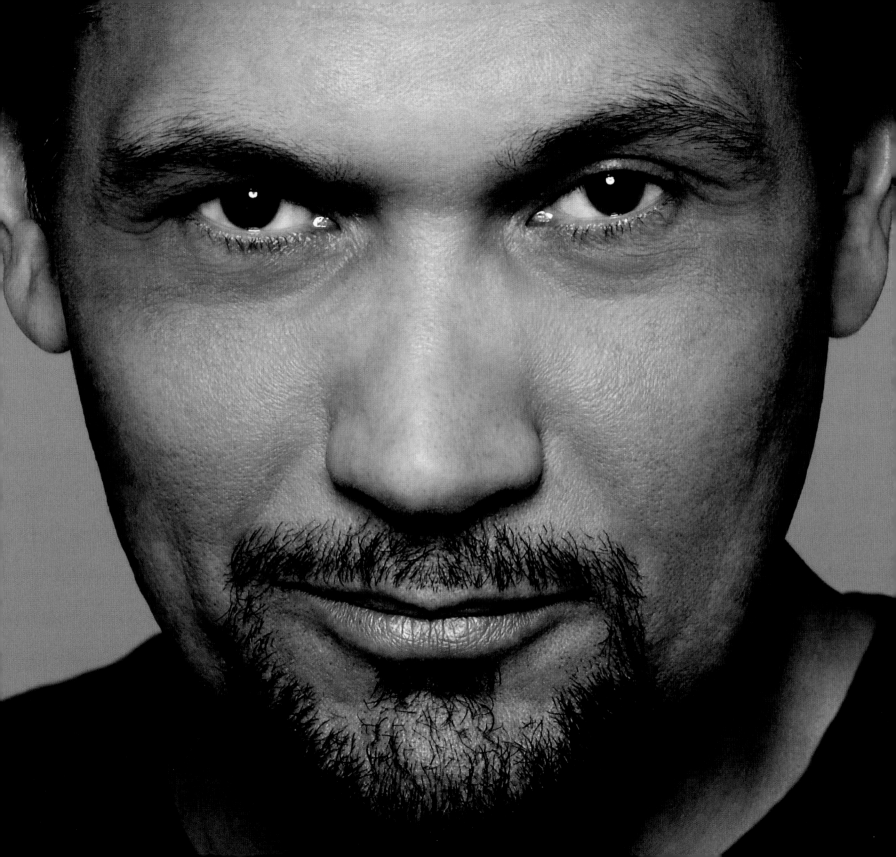

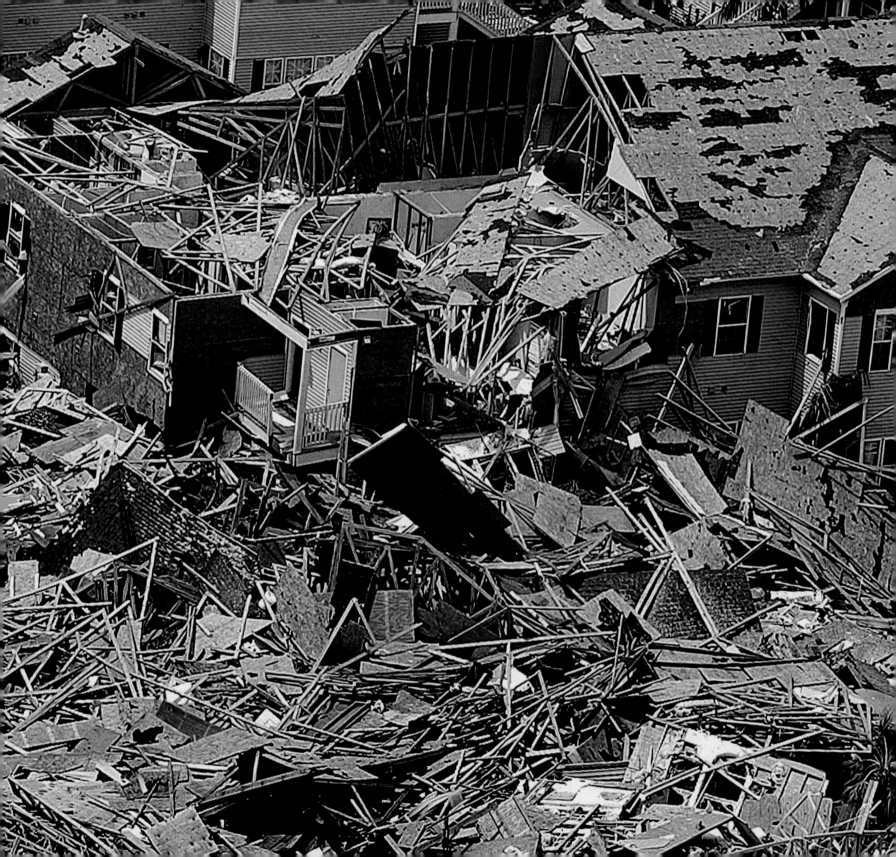

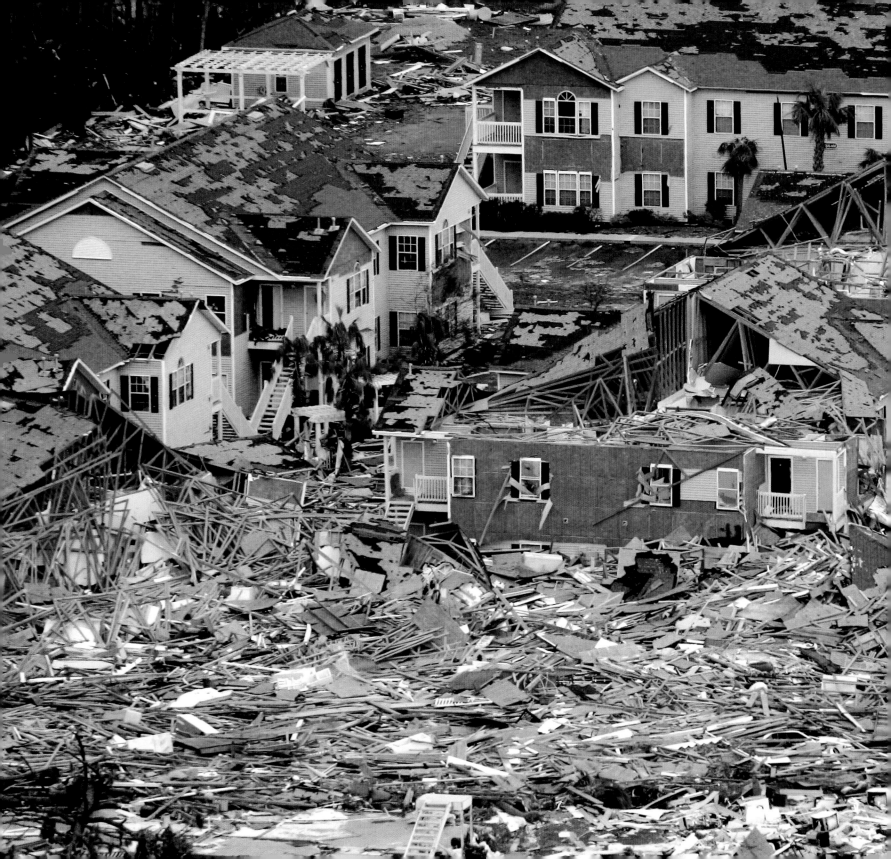

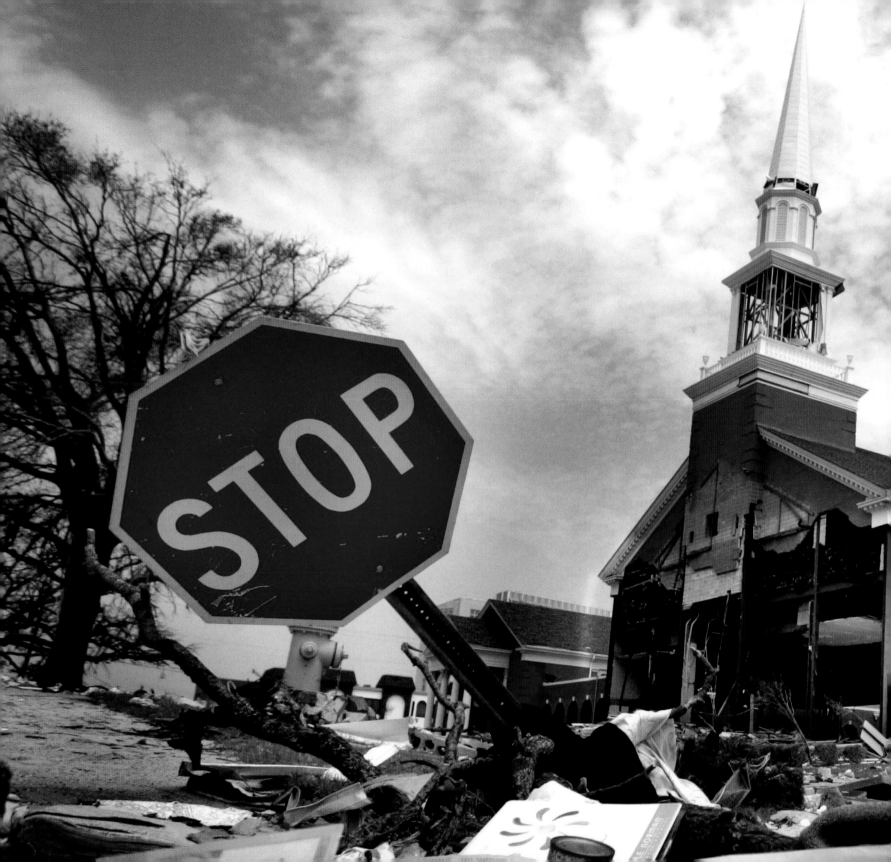

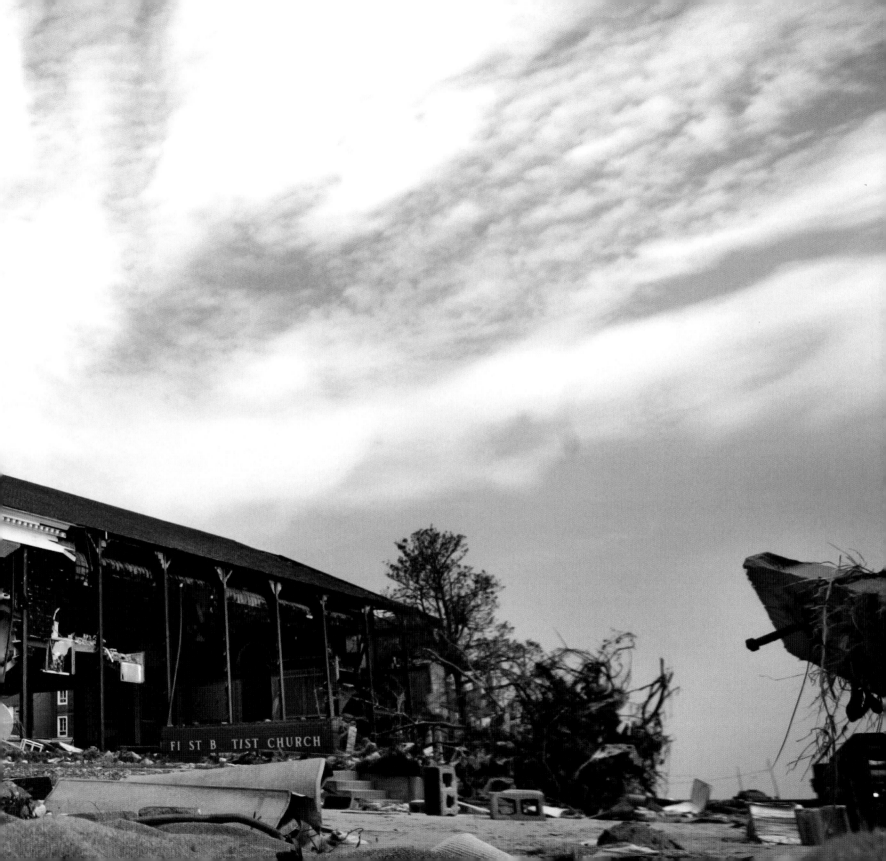

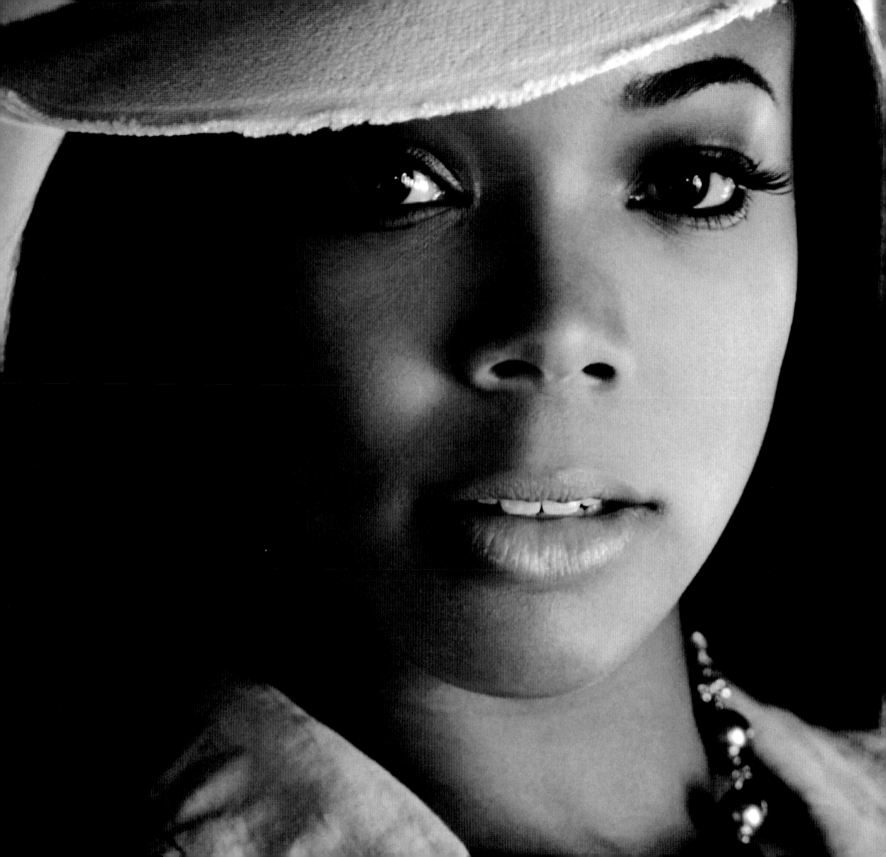

In the face of adversity, our faith is tested. We have choices to make. Lean on your faith. It knows no color. It knows no politics. It knows no class divisions. Faith speaks to humanity. It speaks to dignity. It speaks to all of us. Faith. Always and forever

♡

Gabrielle Union

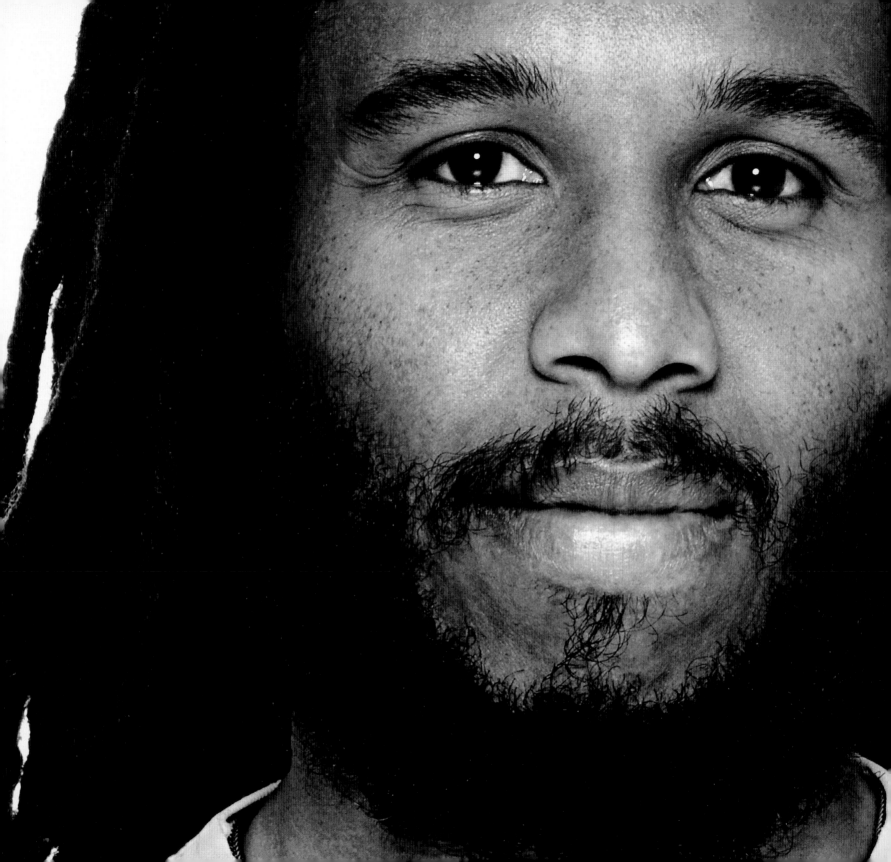

Keep the Faith
Love is the Answer

Jeff Mavis

Dear Survivors —

JE ME SOUVIENS — I REMEMBER — AND
WILL VOTE ACCORDINGLY. OUT OF RESPECT
FOR THOSE WE HAVE LOST, AND WITH LOVE
FOR THOSE WHO WILL FOLLOW US, LET'S
KEEP PLATO'S WARNING IN MIND:

"ONE OF THE PENALTIES OF
REFUSING TO PARTICIPATE
IN POLITICS IS THAT
YOU END UP BEING GOVERNED
BY YOUR INFERIORS."

K.V.js.

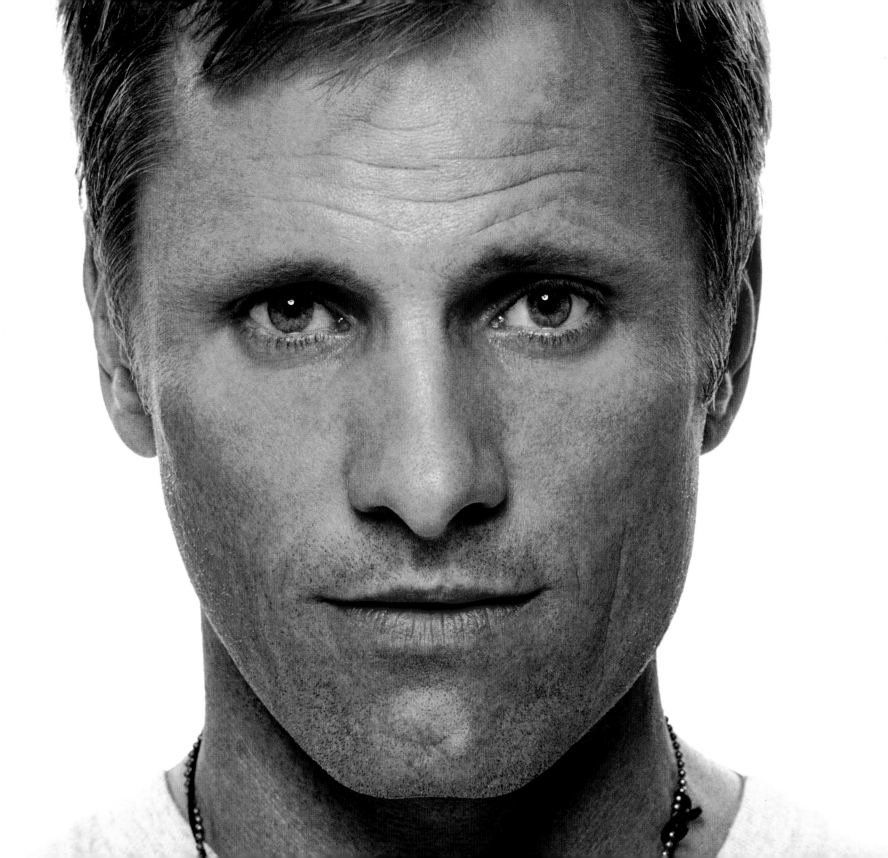

One year ago I watched in disbelief as the coasts
of Louisiana and Mississippi seemed to be washed
away for good. I saw the devastation firsthand when
I spent a few days volunteering in Covington, Louisiana
last Christmas - building homes with Habitat volunteers,
who were there to help perfect strangers. I saw "HELP"
signs scrawled on storefronts in the 9th Ward, and
gutted homes lining streets from Lakeview all the way
down to the French Quarter. That is one New Orleans
I will never forget. But I also saw another more
hopeful New Orleans. I saw it in the eyes of a street
artist, who lost a lot to the storm, but continues to
create with what little she has left. I saw it in
families, cleaning out their homes while wearing facemasks to
block the toxins. These survivors prove that what holds a
community together are not buildings or streets - not
the physical structures that Katrina and Rita washed away-
but the people who live there. The same people whose strength
and courage will help the Gulf Coast not just survive, but
flourish. But as strong as these people are, they still need
our help. Life in the Gulf is getting a little better each
day with support from Habitat for Humanity and the
Red Cross. I may be from the North in Pennsylvania, but
I'll always feel indebted to those helping my neighbors all
across Louisiana and Mississippi when they needed our
help most. Love,
Laura Bushewicz

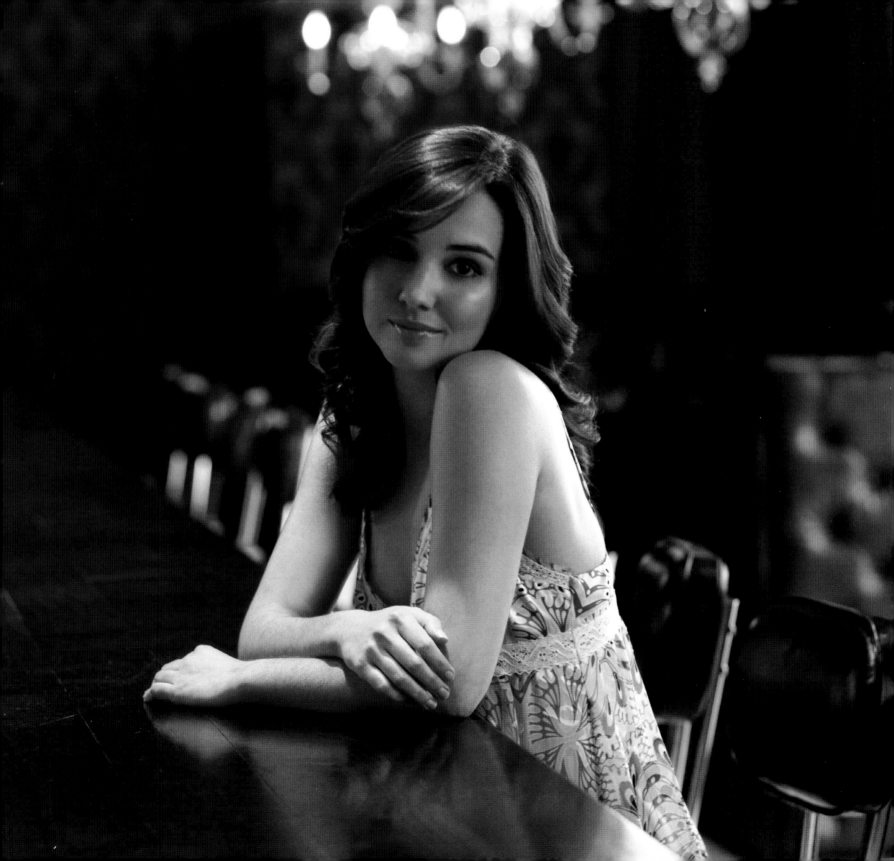

The greatest Angel to work for Humanity
is The Angel of Perserverance
It whispers in our ears to continue onward
To walk forward
To Prevail
It encourages us by acknowledging
that each new breath we take
moves us into the next
To those of the South who endured
the Hurricane Katrina
Thank You for being that
Angel of Perserverance
for me and the world
Reminding us of the beauty
that awaits us tommorow
Whispering to us the Divine Act
Of continuing On
To Create Anew
Giving all of us hope for a
New future through
Your Divinity

Forest Whitaker

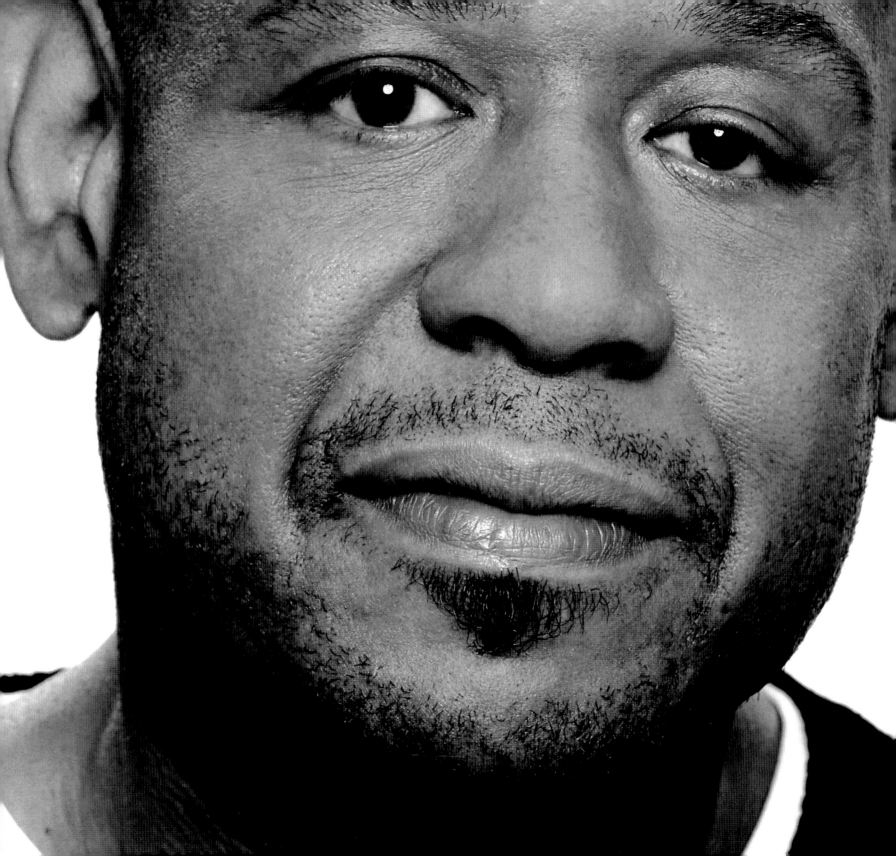

Courage

Faith

Determination

The foundation to Rebuilding

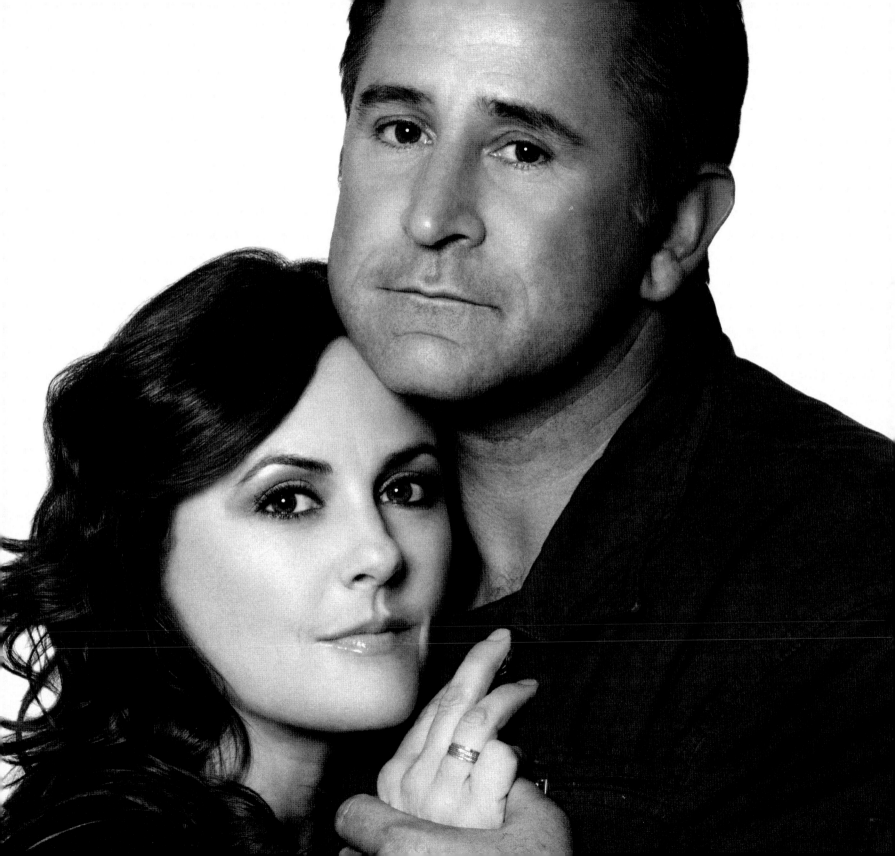

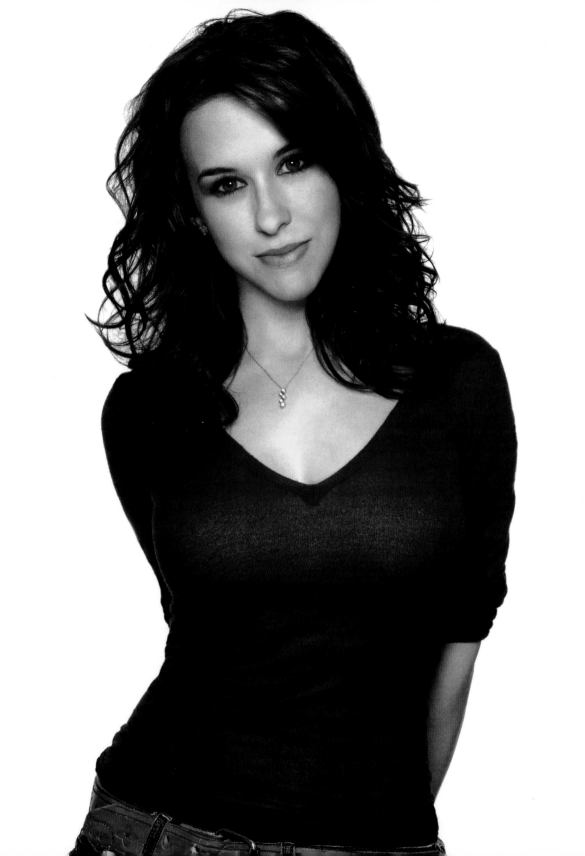

I'm from Purvis, Mississippi.
- a Southern girl at heart
My family was affected by
Katrina's devastation. I
feel your pain. After visiting
the area, I also feel the
tremendous power of your
hopeful spirit... such strength.
My prayers are with you always
for a complete restoration of
your homes, lives, and hearts.
We won't forget... God Bless you.
 Much Love,
 Lacey ♡
 Chabert

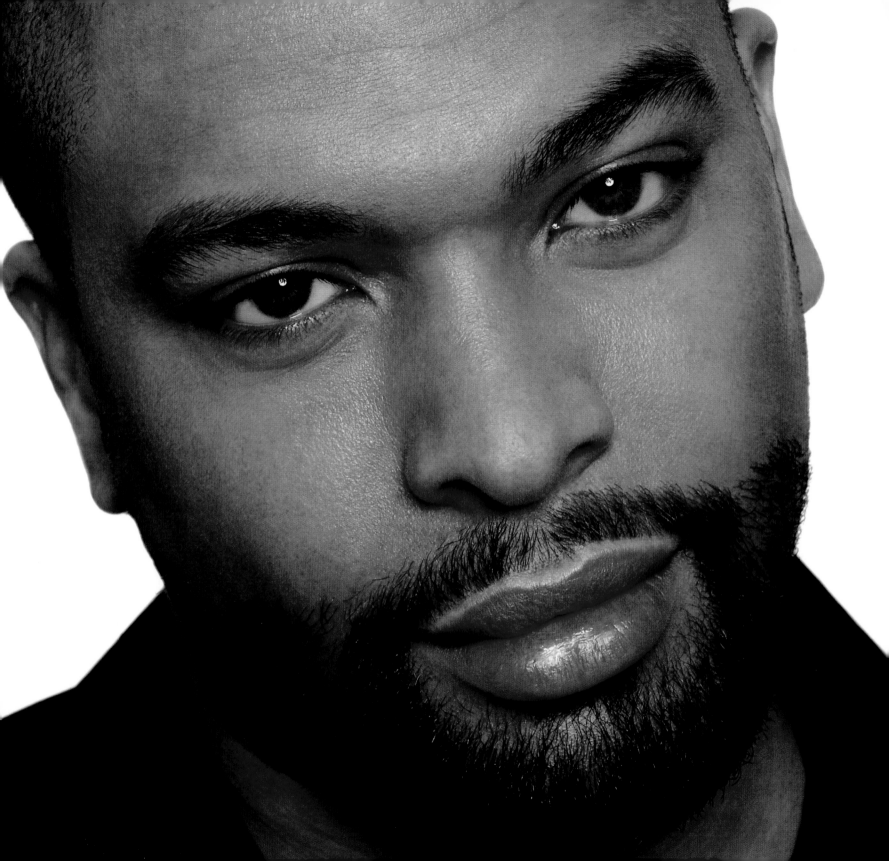

Dear N.O.

N.O. We have not forgotten.

N.O. We have not turned our backs.

N.O. You are not alone.

YES We will do this together!

DeRay O~

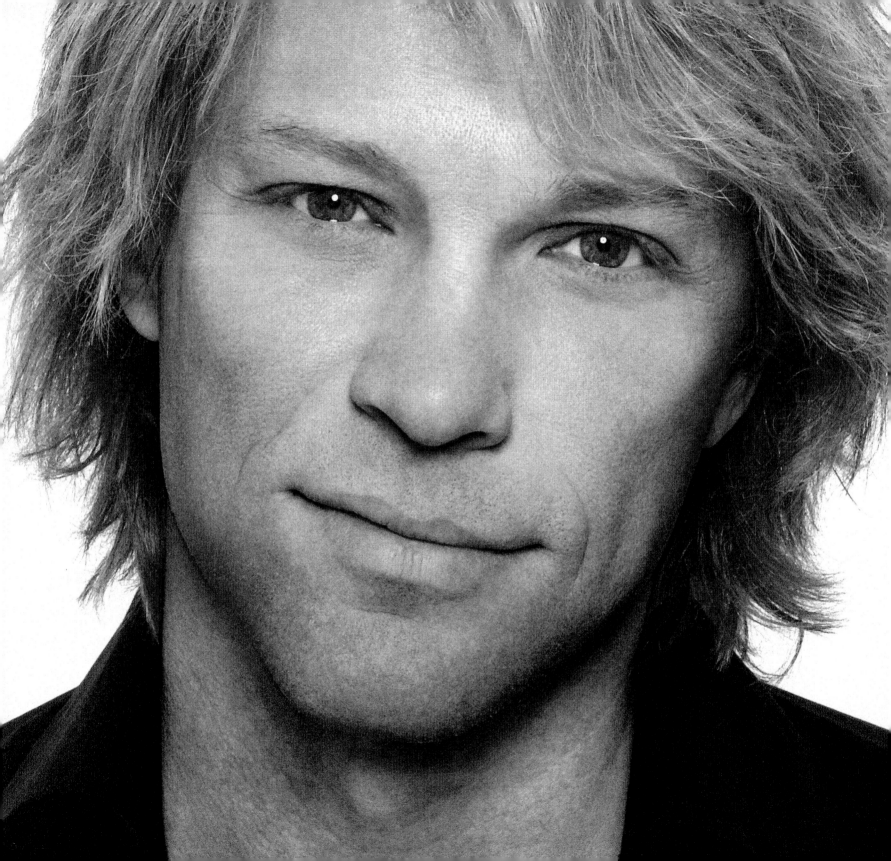

LOVE. . . .
one size Fits All.

It's too bad it takes a hurricane
to see the real America on TV and
I have to say that when I saw the
families frantically looking for their
loved ones I wished I'd had a family
like that. With that much pure love
for one another. I will never forget you.
I will help. Thank _you_.
 Love
 Tom Arnold

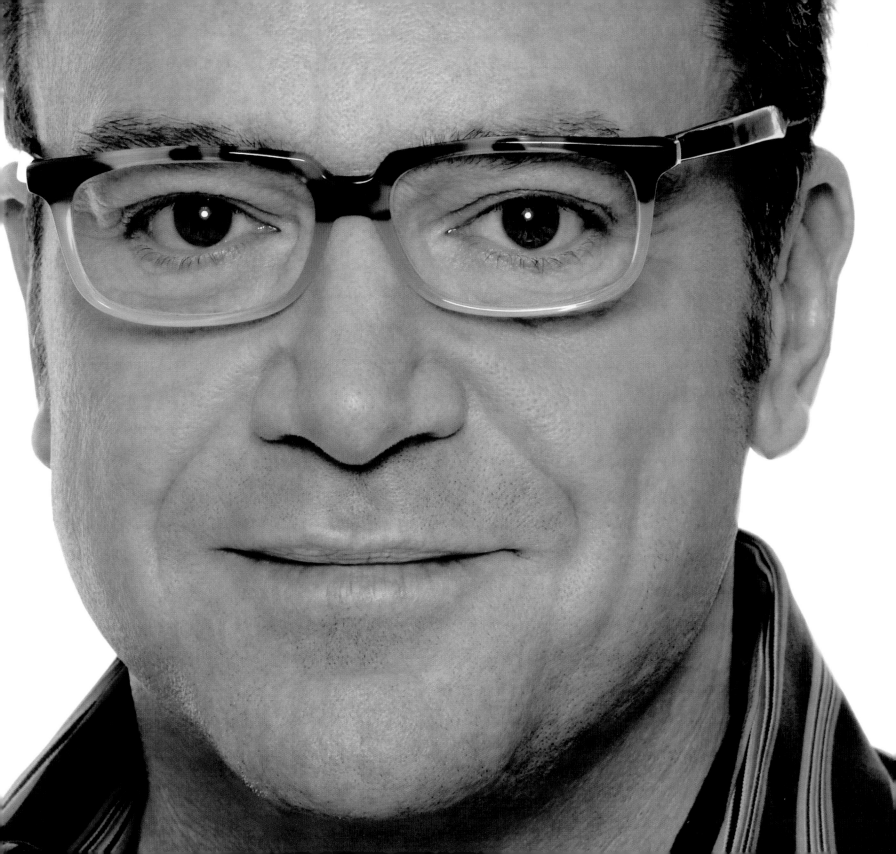

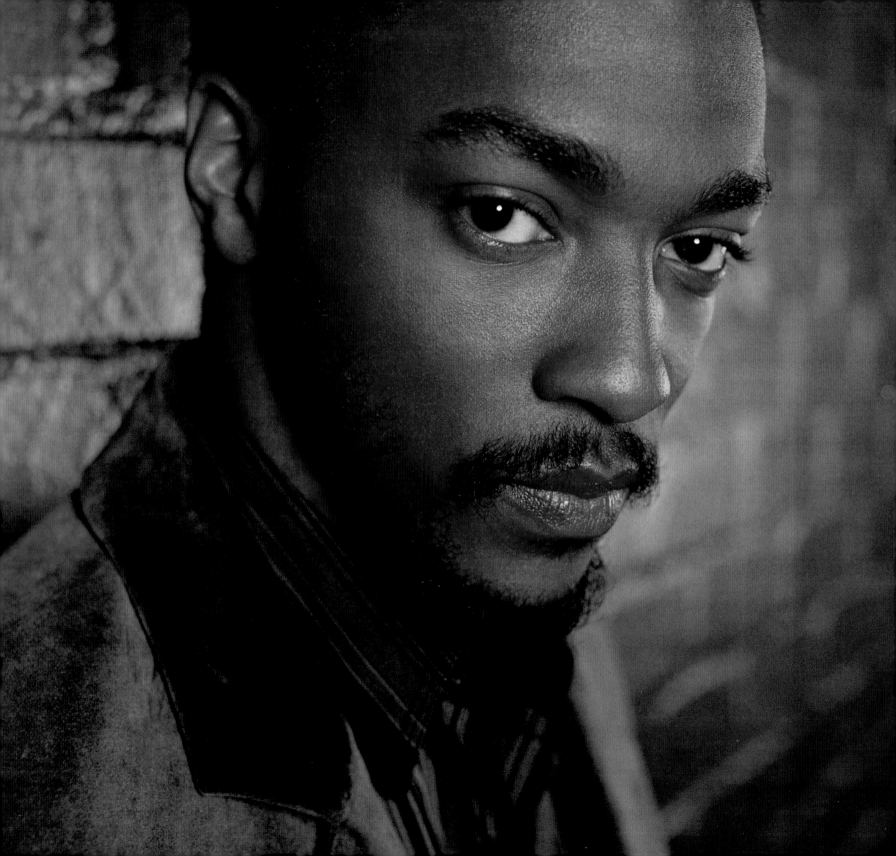

For the 7th wArd
I Live
For my city...
I'll Die

Bring New Orleans BAck!

I Love
My people!!!

I AM
Banner
oO

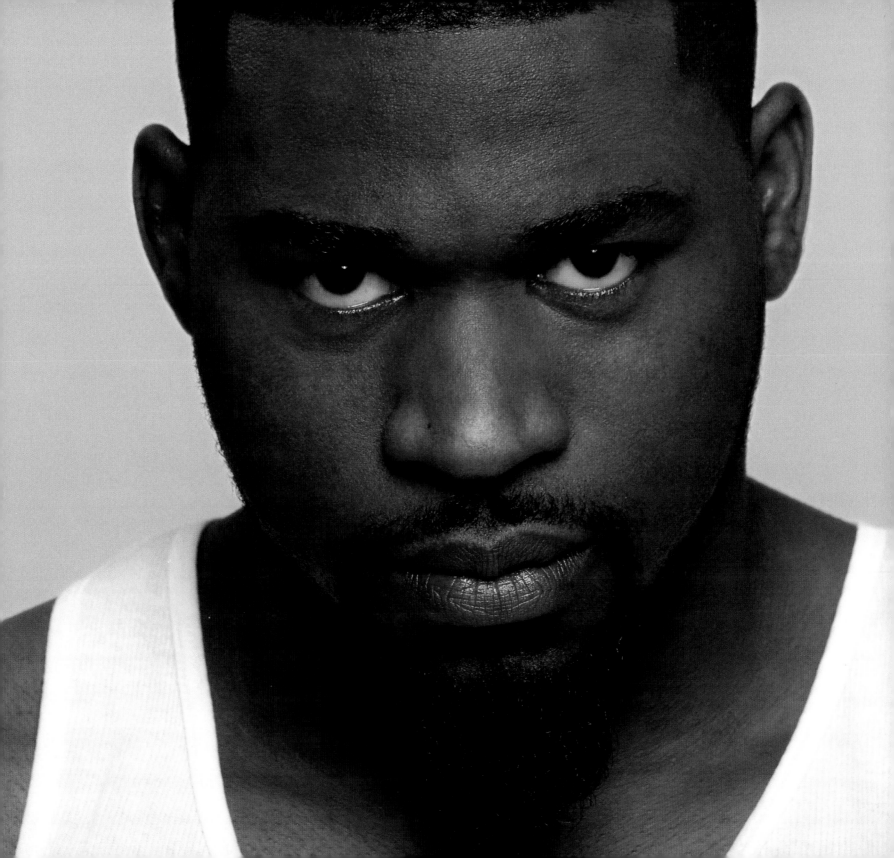

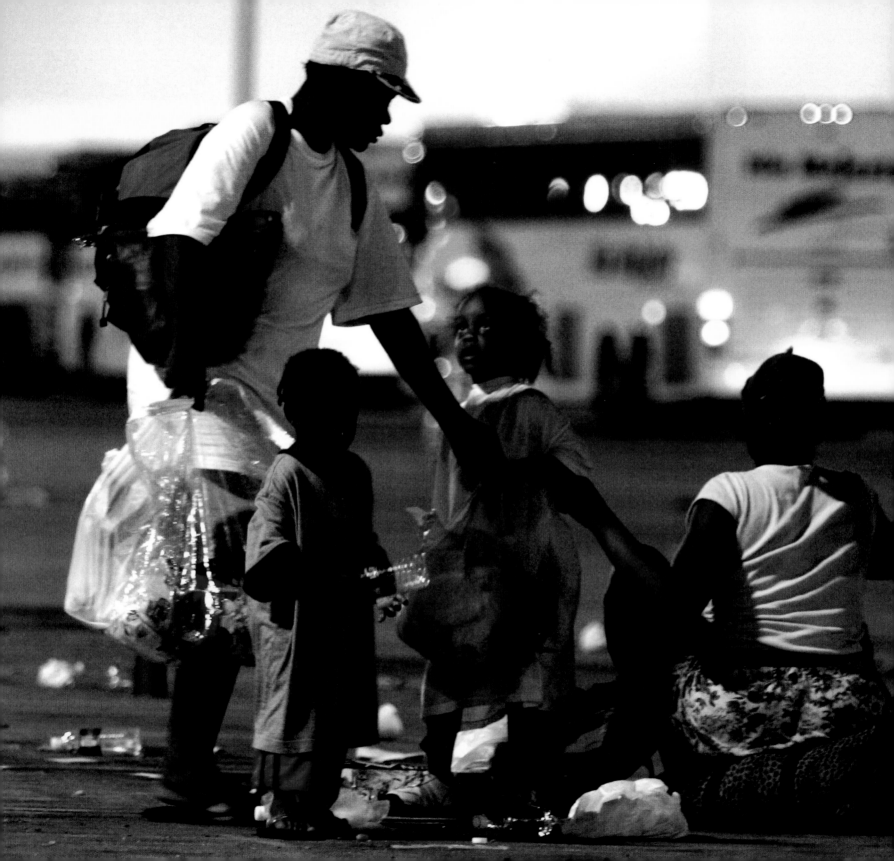

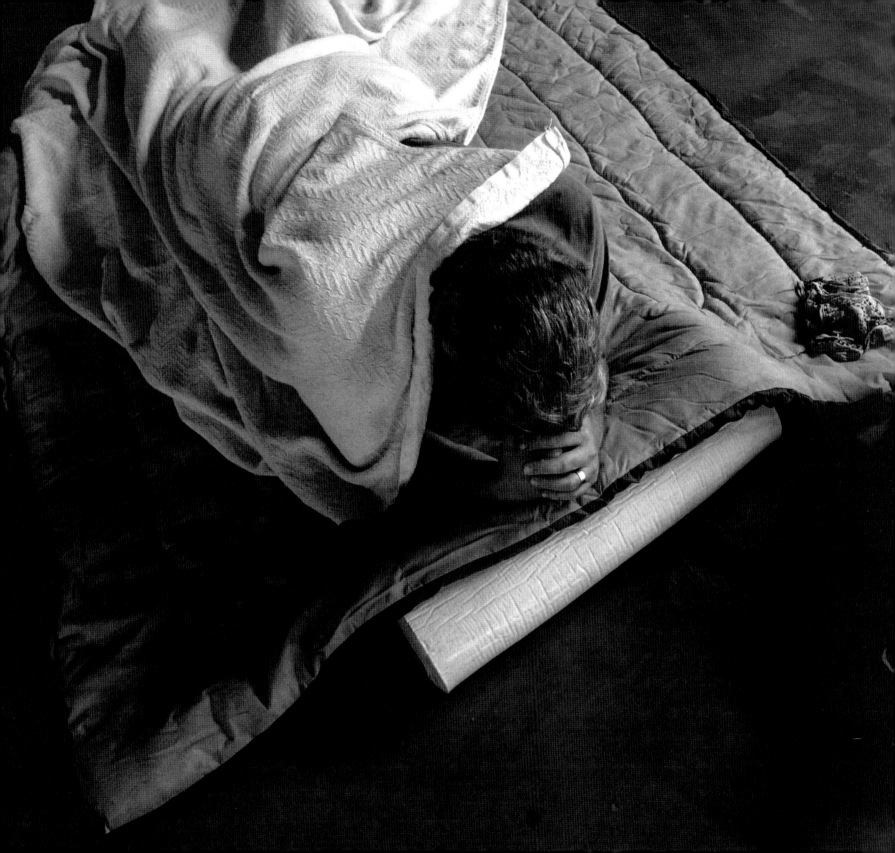

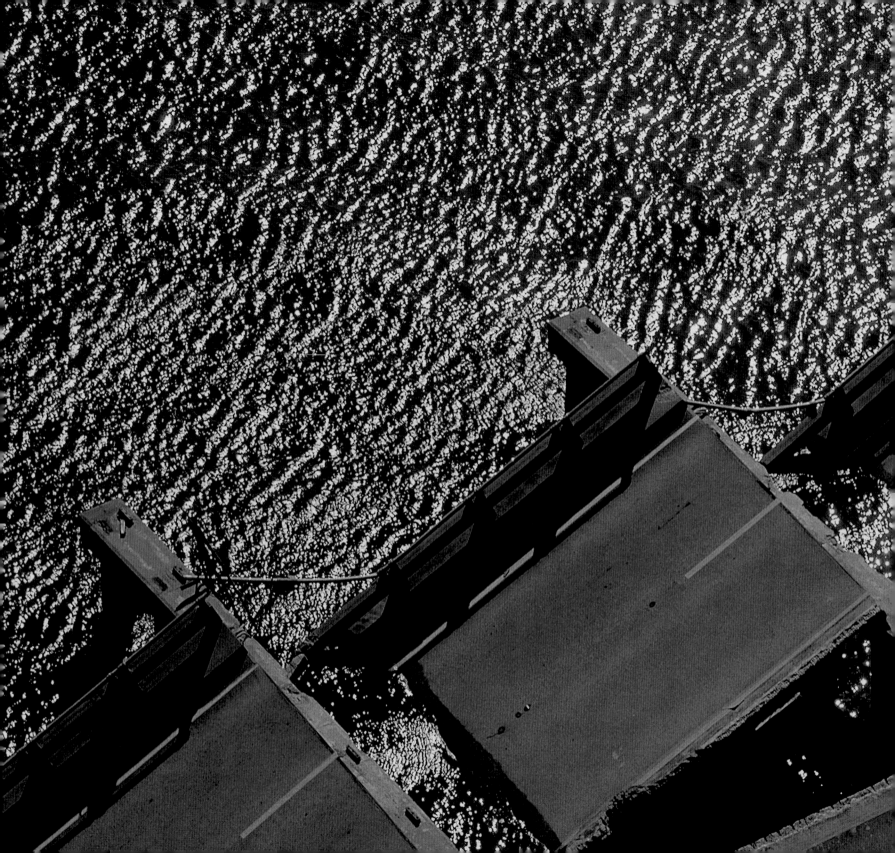

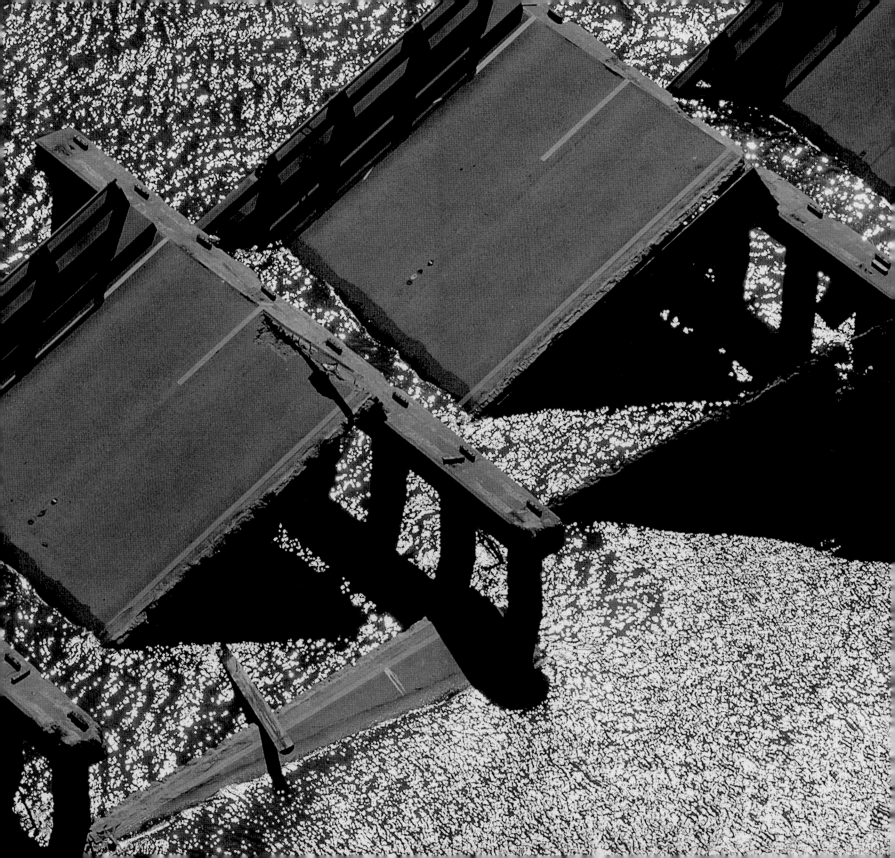

She beat you,
but she didn't break you!!
Stay strong!!

Shawn Ashmore

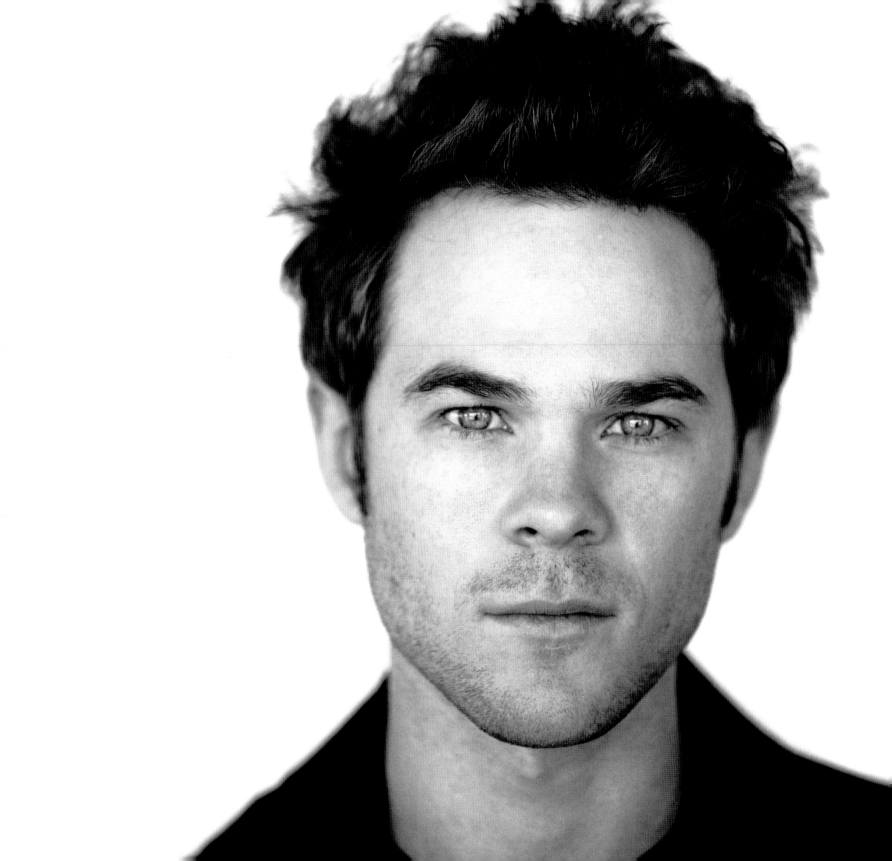

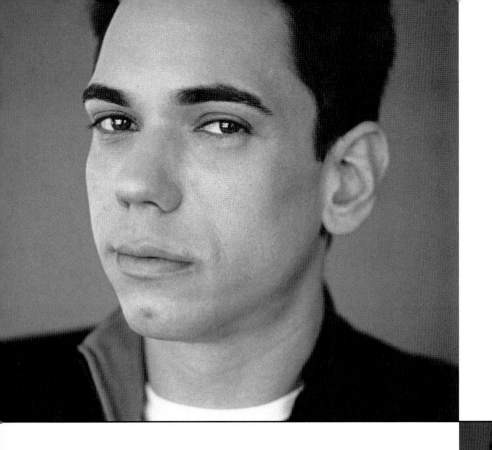

NOW IS THE TIME FOR A
NEW ORLEANS ... AND
FAITH IS THE BLUE PRINT

DS

Our cultur & way of life are
too precious to allow any disaster-
natural or man made to destroy it.
Your efforts to rebuild in the face
of such devastation are a testament
to the indomitable southern spirit.
My thanks & prayers are with
you all.
 Love,

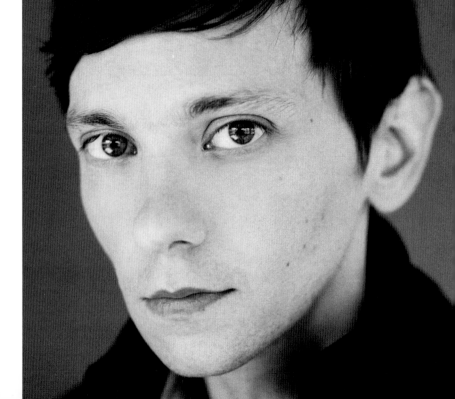

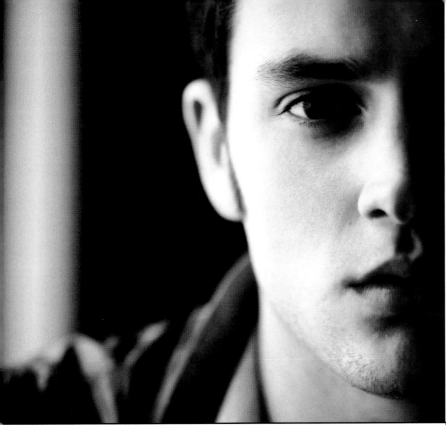

"Struggling. Oh, how we struggle.
And the more we avoid it, the greater the struggle
becomes, until we realize the struggle is the blessing.
Progressing.
Changing.
Evolving.
Growing."

 - the Gift of Gab.

Keep the spirit.. we need it, desperately.

Everyone falls. History
will judge us by how we
rise after the fall. Rise
New Orleans, Rise!!

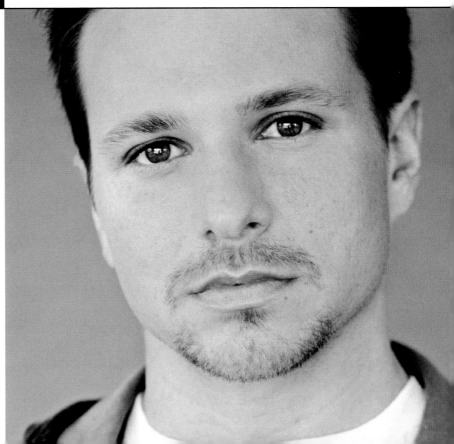

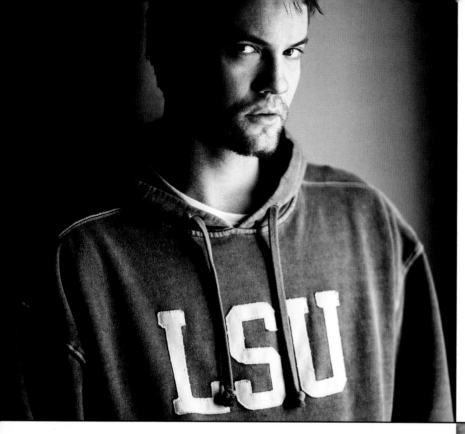

My Thoughts & Prayers Are With You & Your Families
Stay Strong.
With Love,
Shane West (hometown Baton Rouge)

YOURS IS A MAGICAL CITY
AND
YOU ARE AMAZING PEOPLE
YOUR PAIN,
YOUR COURAGE
LIVE IN OUR HEARTS ALWAYS
AND
YOU ARE NOT FORGOTTEN.
PEACE & LOVE,

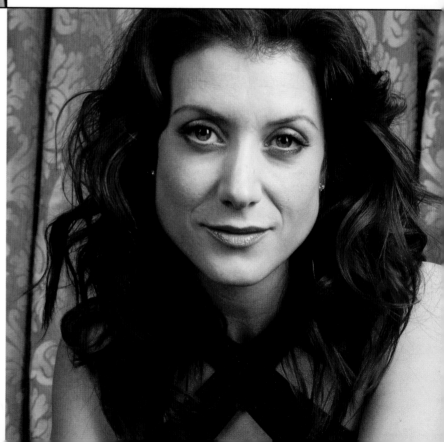

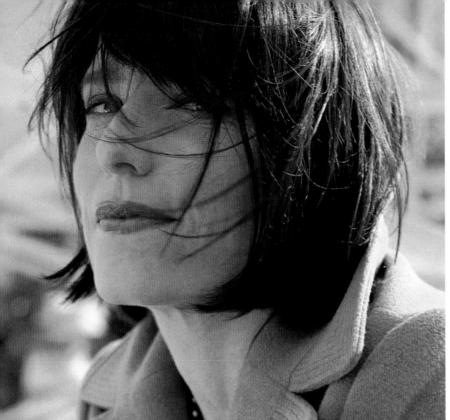

TRY TO PRAISE
THE MUTILATED WORLD
by
ADAM ZAGAJEWSKI

TRY TO PRAISE THE MUTILATED WORLD.
REMEMBER JUNE'S, LONG DAYS,
AND WILD STRAWBERRIES, DROPS OF ROSÉ WINE.
THE NETTLES THAT METHODICALLY OVER GROW
THE ABANDONED HOMESTEADS OF EXILES.
YOU MUST PRAISE THE MUTILATED WORLD.
YOU WATCHED THE STYLISH YACHTS AND SHIPS;
ONE OF THEM HAD A LONG TRIP AHEAD OF IT,
WHILE SALTY OBLIVION AWAITED OTHERS.
YOU'VE SEEN THE REFUGEES GOING NOWHERE,
YOU'VE HEARD THE EXECUTIONERS SING JOYFULLY.
YOU SHOULD PRAISE THE MUTILATED WORLD.
REMEMBER THE MOMENTS WHEN WE WERE TOGETHER
IN A WHITE ROOM AND THE CURTAIN FLUTTERED,
RETURN IN THOUGHT TO THE CONCERT WHERE THE MUSIC FLARED.
YOU GATHERED ACORNS IN THE PARK IN AUTUMN
AND LEAVES EDDIED OVER THE EARTH'S SCARS,
PRAISE THE MUTILATED WORLD
AND THE GRAY FEATHER A THRUSH LOST,
AND THE GENTLE LIGHT THAT STRAYS AND VANISHES
AND RETURNS.

Melissa Walter

AWAKE FROM YOUR

SOMBER STORM SLUMBER

CRESENT CITY, HOW

I LOVE YOU.

LAISSE LE BON TEMPS ROULER !

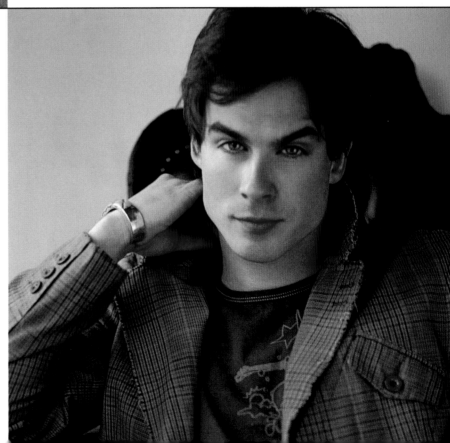

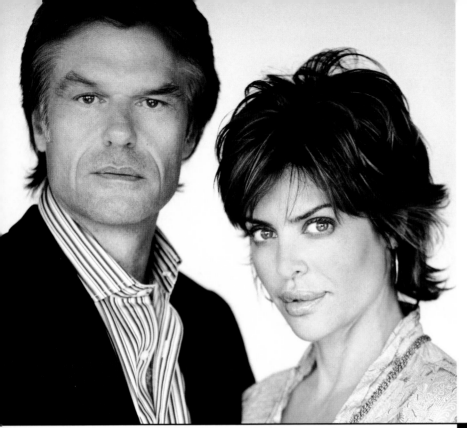

HOPE

Believe ♡

LOVE

Lisa Rinna

We will never Forget!
We will Always Help!
You will Rise Again!

Harry Hamlin

Sending you so much
love, faith, strength ; grace.

a nation's prayers walk with you...
and God is even closer than that ☺

So much love,

Regina Hall

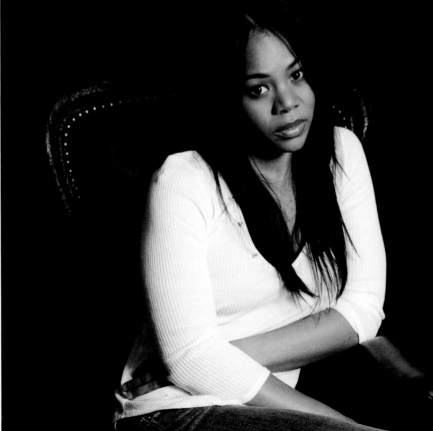

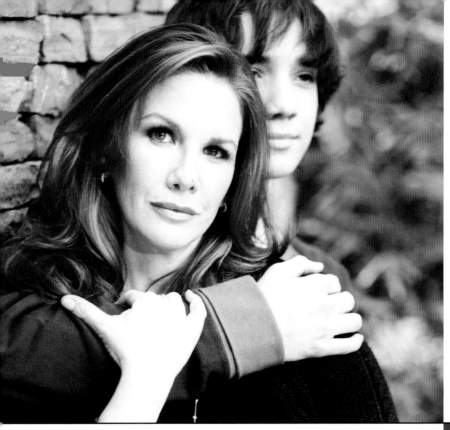

It is said that those who forget History are doomed to repeat it.

Never Forget!

NEVER!!!

Melissa Gilbert

« My memories are me, my pain set me free. Free to believe that I am not weak. I'm strong like the sky, reflecting the sea. So I can defeat the sorrows in me.»

LOVE & Respect,

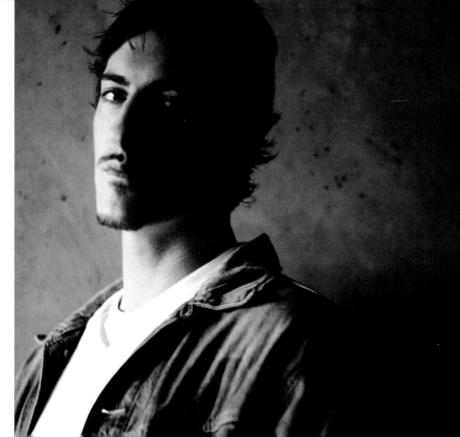

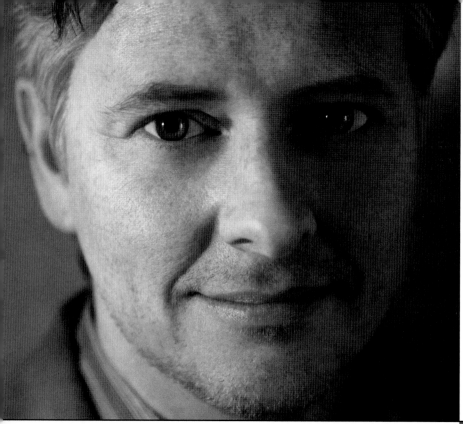

New Orleans, you will be chocolate again.
Perhaps, with a fresh rasberry glaze and a
light sprinkling of powdered sugar.

The south with repair and return and Katrina
will fade from your memory much like
the eighties pop group it was named after.

All the best,
Get drunk & sing

David Foy

The People of New Orleans are
known for their joie de vivre and
sense of style - style in music,
in cooking, in architecture, in the
way they live their lives to the fullest.
No one knows what the new New Orleans
will look like, but there's one thing
we can all be sure of - it'll be
rich with Style!
 Keep Creating!
 Susie Coelho

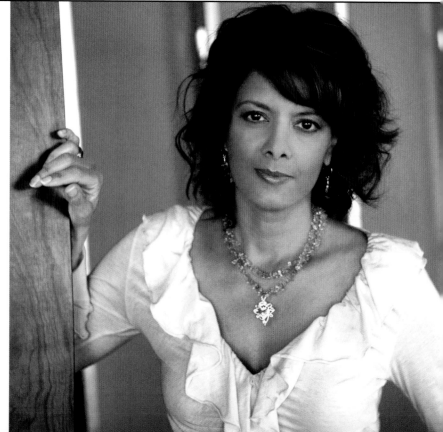

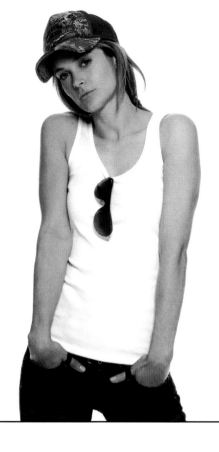

The world is witness to your tragedy.
Though your loss is great, your spirit is greater.
We watch with admiration as you persevere.

Rachel Blanchard

At first glance you seem like
the victims
but look again...
The light of your courage, the
brightness of your perseverance,
Your mountain of faith...
You, my friends, have saved us all.

love
Nikki & Boris

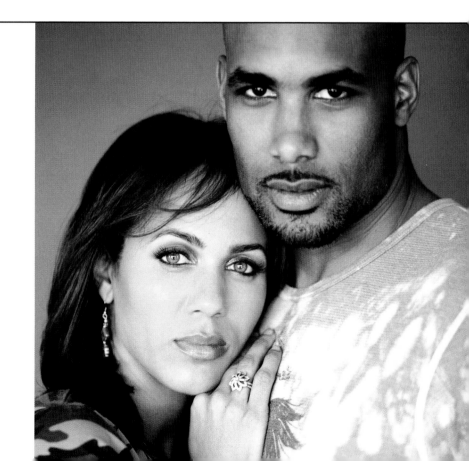

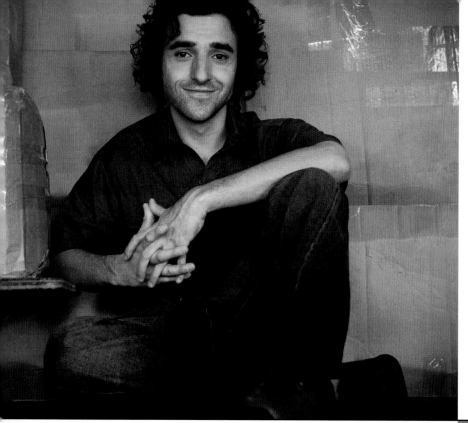

STRUGGLE DOESN'T HAVE TO BE A REALITY
A SOUL CANNOT DROWN
LOVE IS FOREVER thirsty FOR MORE LOVE

The FUTURE IS ALWAYS MORE PROMISING
than the PAST
MISTAKES CAN BE UNDONE.

DO EVERYTHING YOU CAN, DO EVERYTHING YOU
MUST, TO HELP HEAL the HEART of
AN AMAZING PLACE, NEW ORLEANS, HOME OF
the GREATEST PEOPLE I'VE EVER MET.

In times like This we
have to remember that our
Struggles make us Stronger.
Keep your faith! You will Soon
be the Strongest city in
the world!

Jonathan Pruett

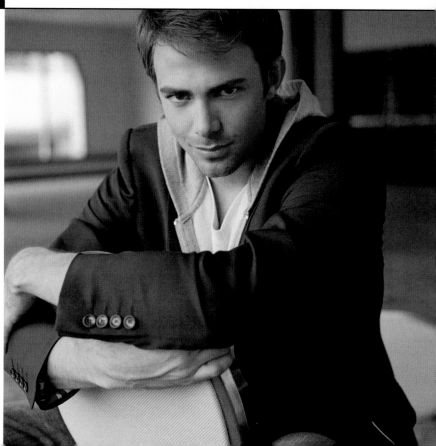

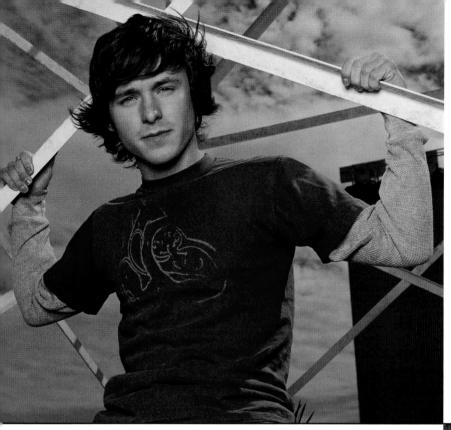

This is a stand against loneliness and isolation

This is one foot forward into the sunrise of faith

This is a monument for the existence of hope

This is my prayer for the abundance of love

— Marshall

To those who have lost...
Family
Friends
Beloved beasts
Homes
Neighborhoods
Communities...

So very much...

You have NOT been forgotten.
Rebuild
Rebuild
Rebuild

Strength & love to you,

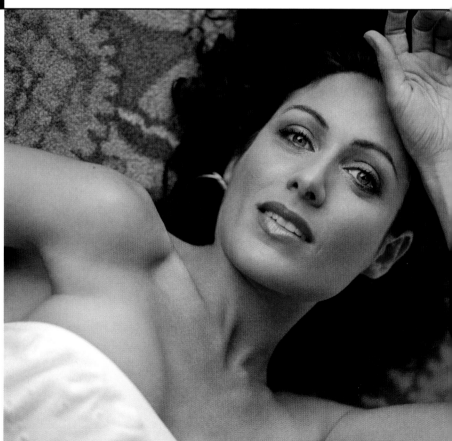

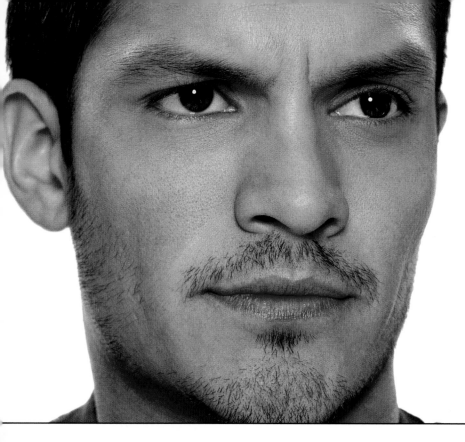

It is saddening to think that it takes
a national disaster to bring people together.
But the worth of a nation can be measured
by how it treats its citizens when they are
at their lowest. Only time will reveal ours...

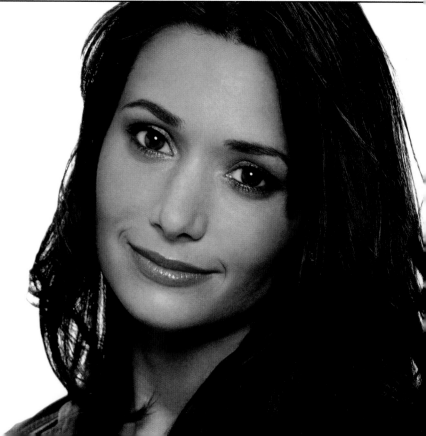

For all in the South.
Never Stop...
 believing
 dreaming
 laughing
 singing
 dancing
 smiling
 and
 loving
for it is your faith &
courage that inspire your
children and us all.

 Jessica
 Denay

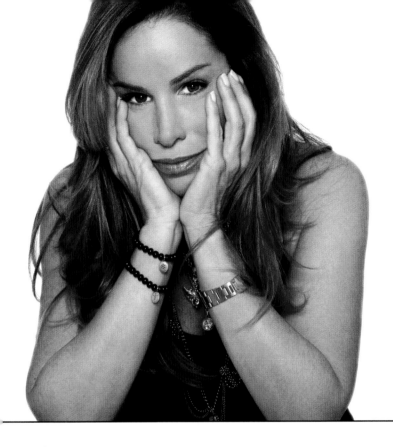

"Those who forget the past, are doomed to repeat it."

May we never forget...

Love, hope, faith, and courage.

XOXO—

Melissa Rivers

ADVERSITY AND TRAGEDY SOMETIMES, MOST OF THE TIME, BRINGS OUT AND REVEALS THE TRUTH.... I feel saddened that the response to this was so slow.... Is caring and concern only reserved for the privileged? when it is, it is a society in decline.... thank God for journalists and broadcasters.

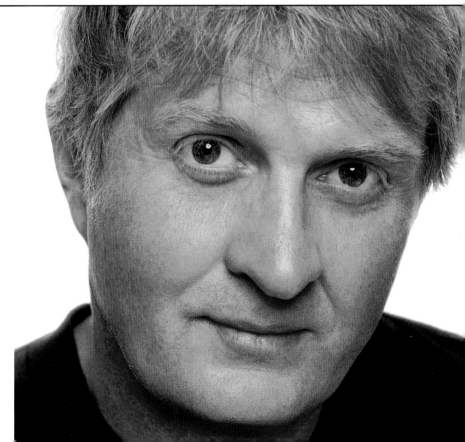

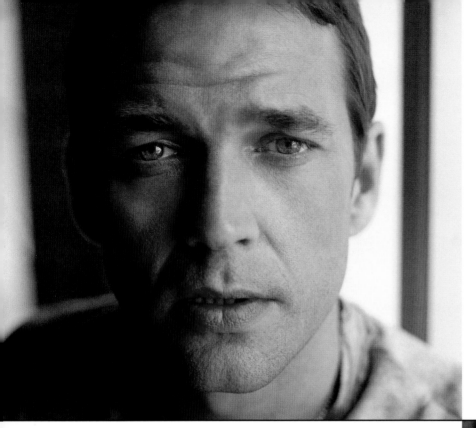

TRY AND SEE THE WORLD
THROUGH THEIR EYES. PLEASE HELP
IN ANY WAY YOU CAN.
GOD BLESS
Dougray Scott

their hearts & voices
a rising tide
a force without retreat
to stand & shout
I am here
& will remain forever

Kelly Hu

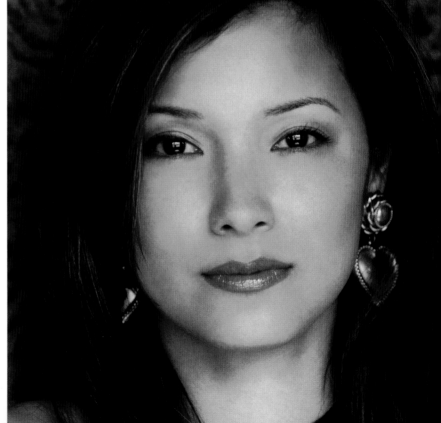

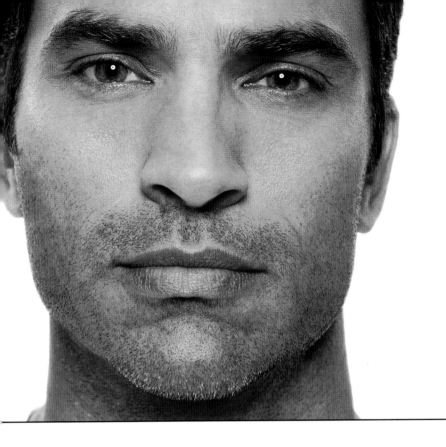

To all my wonderful friends
down in Lake Charles,
Calcasieu Parrish, Cameron
and Little Chenier,
 I send my prayers for
a speedy recovery – I have
never met a better group
of people.

 Je t'aime,

 Tom Schaed

Love is truly the only way we
can get through any adversity.
New Orleans I send you,

 Love!

 Tony x.

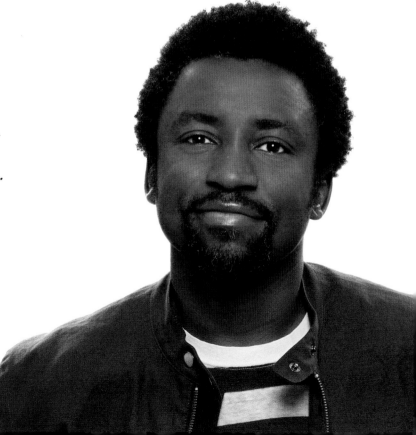

GOD LOVES YOU
& SO DO I . . .
STAY STRONG!!

ALL MY LOVE,

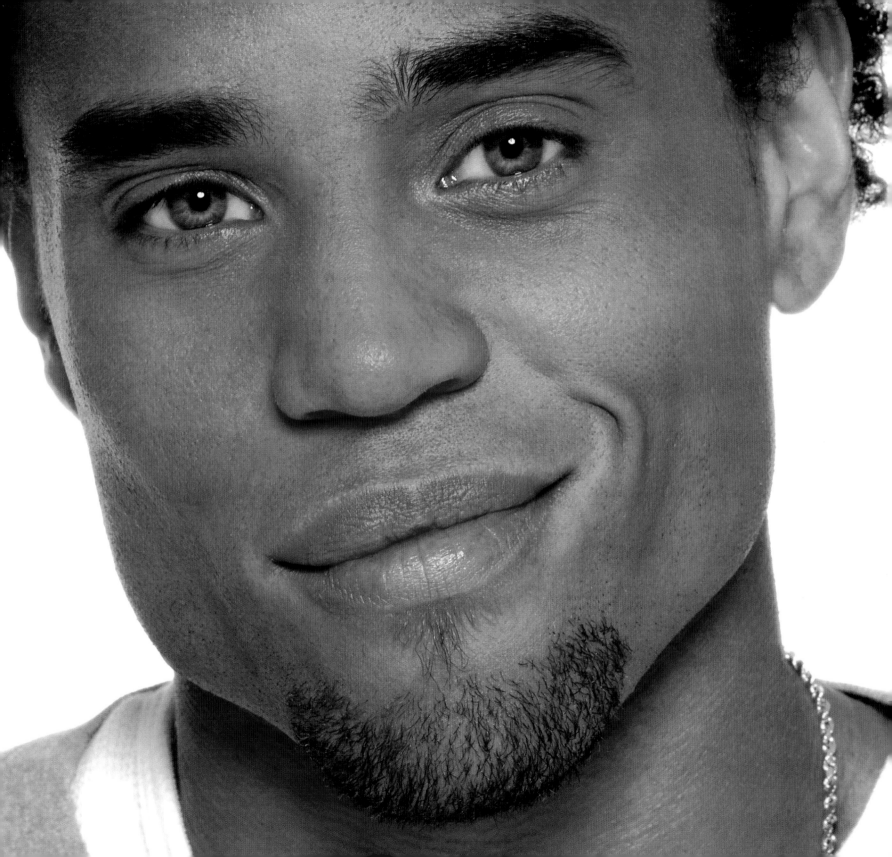

God Bless New Orleans.

Home of the BRAVE !

"JC"

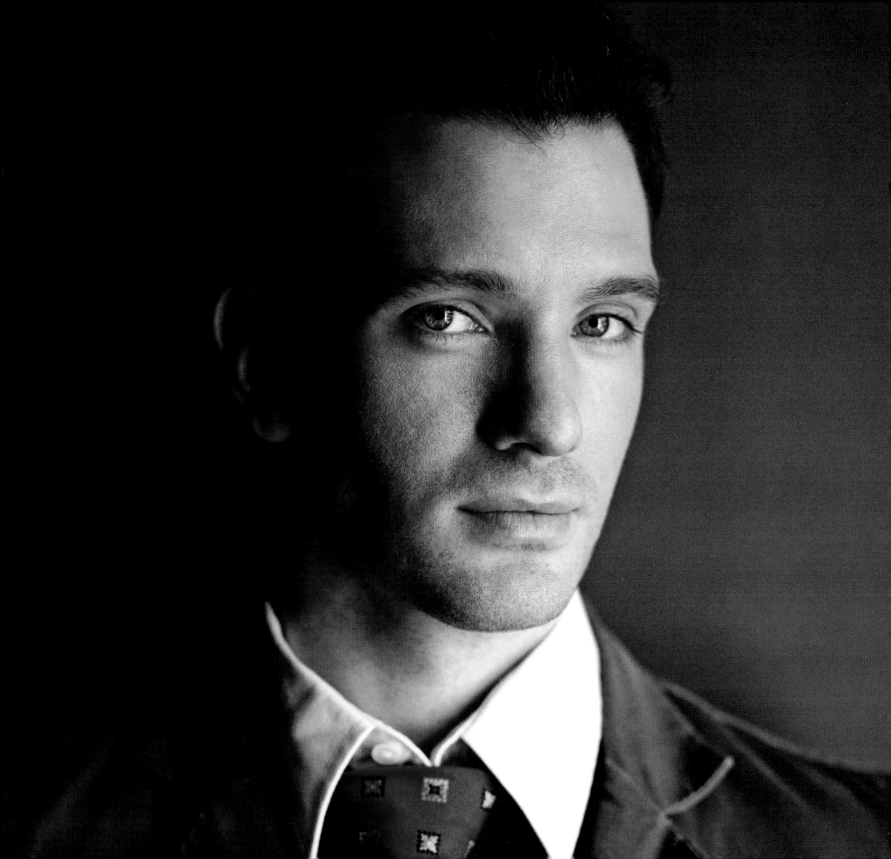

Still I Rise

....

" Out of the huts of history's shame
I Rise
Up from a past that's Rooted in pain
I Rise
I'm a black ocean, leaping and wide,
Welling and swelling I bear in the tide.
Leaving behind nights of terror and fear
I Rise
Into a daybreak that's wondrously clear
I Rise
Bringing the gifts that my ancestor's gave.
I am the dream and the hope of the slaves.
I Rise
I Rise
I Rise.

... from Maya Angelou's lips
to God's ear.

with love and hope
Annie Pris

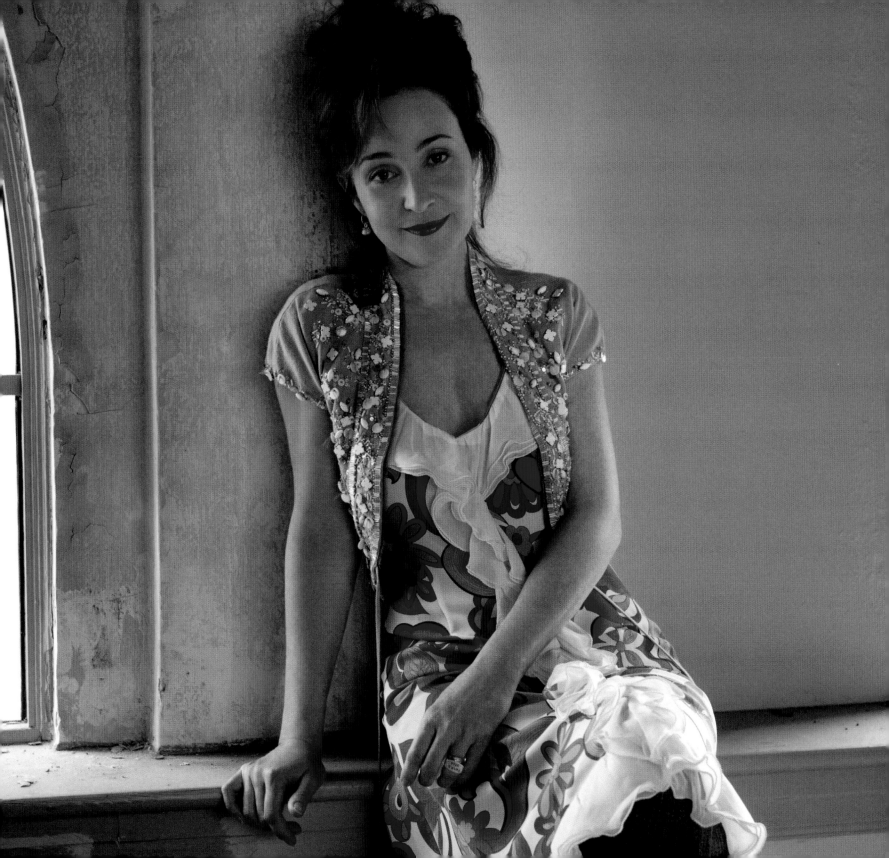

Thinking of u

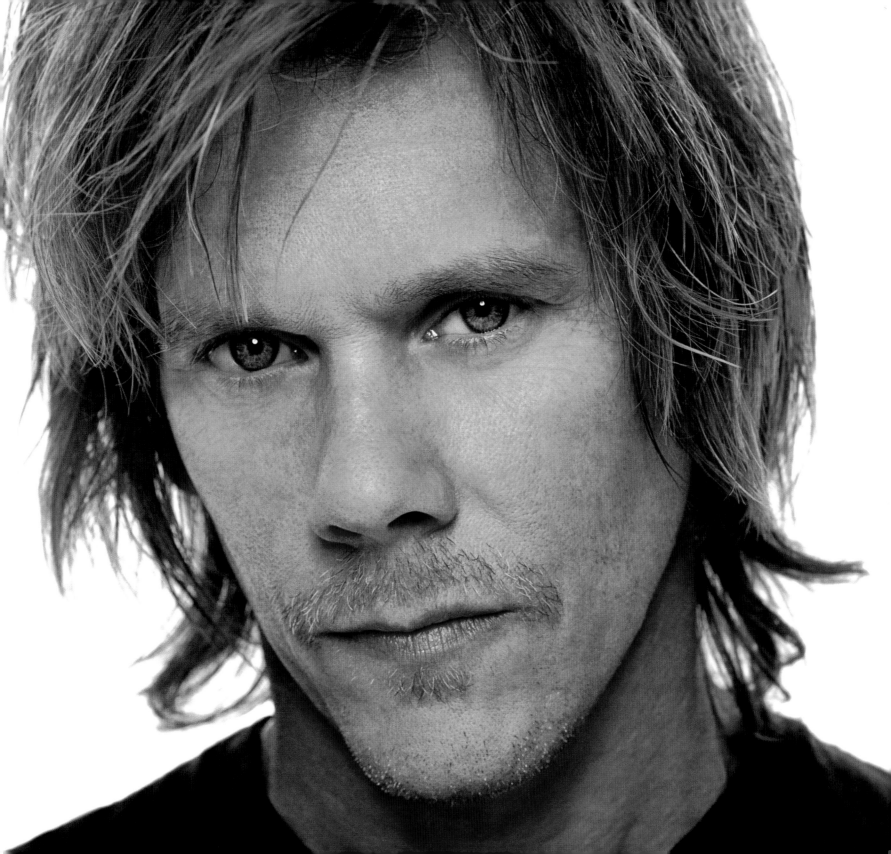

All of you will
never be forgotten....
and we will not stand
silently in the wake
of human suffering.

With love

[signature]

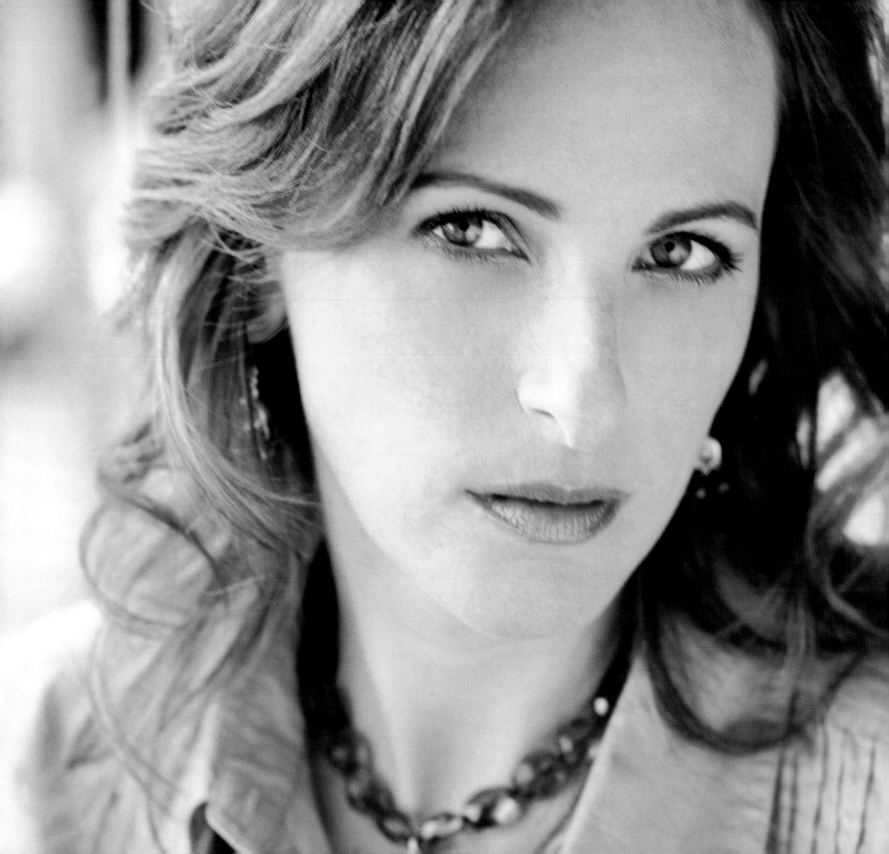

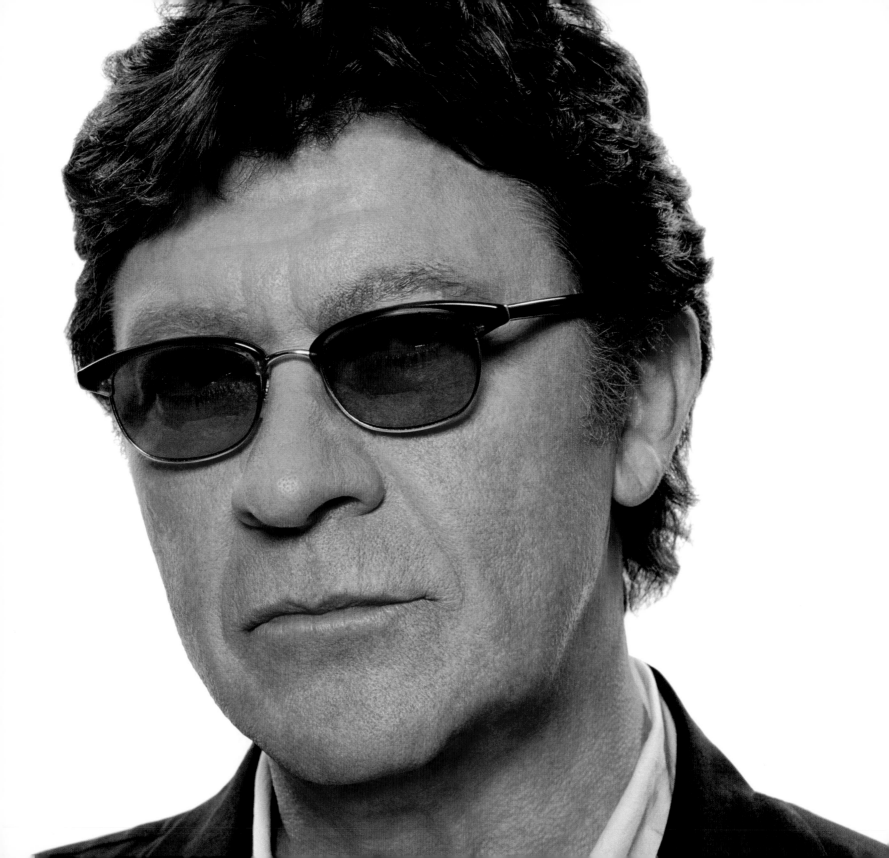

We should never let the spirit
of New Orleans fade away, as long
as we can possibly help.
It's music, culture, architecture
& food are unique in the world.
New Orleans is a treasure that
should always be supported & protected.

Robbie Robertson

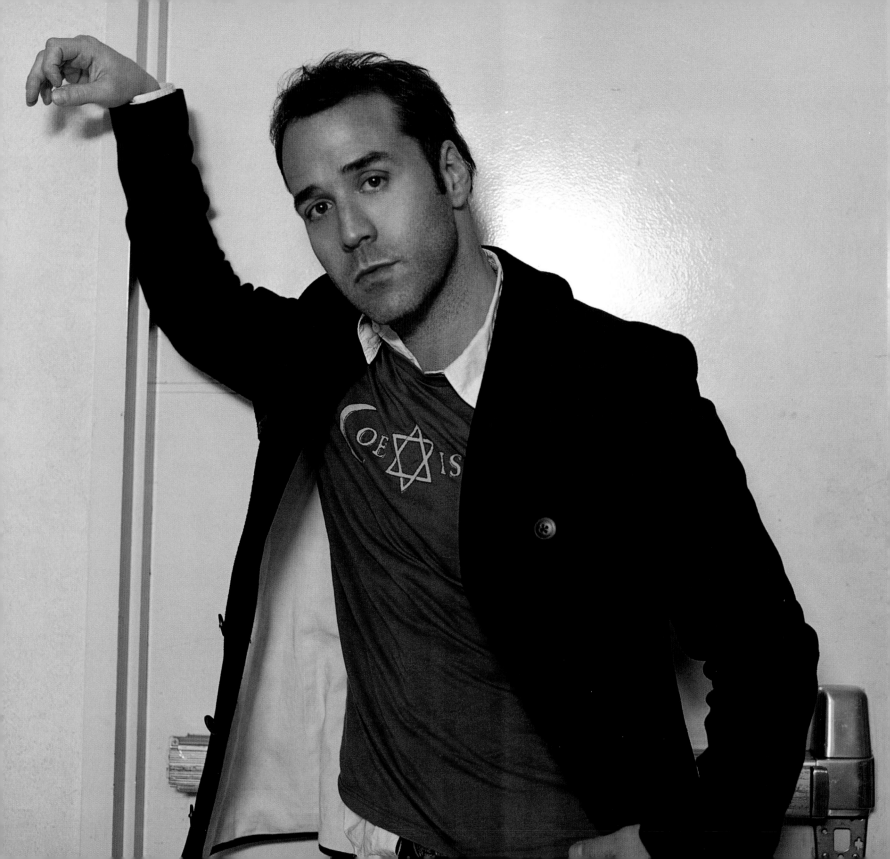

We need to know the Truth
my friends so give it to us.
I grew up with the Mantra
"Tell the Truth and Run"
Now i say "Tell the Truth
and STAY." Rise

TALENTED beautifull
People Rise.

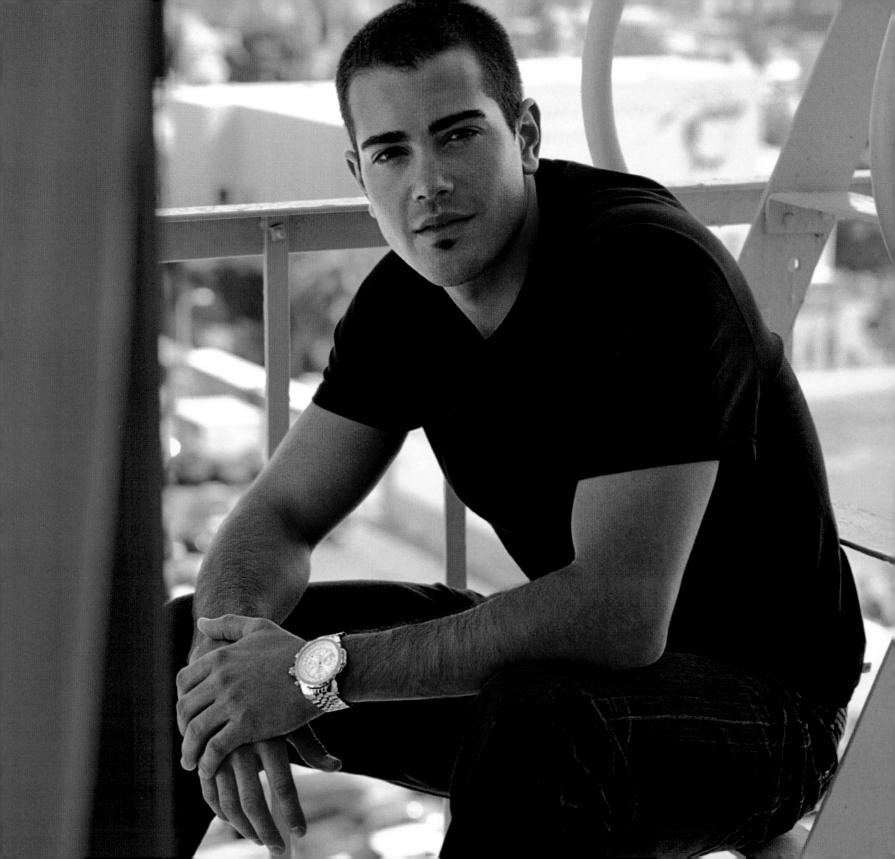

Our hearts AND PRAYERS
ARE WITH YOU ALL.

Your COURAGE is truly
AN INSPIRATION.

Thank you for teaching me to see the
Tragedy
Need
Kindness
Humanity

I look forward to meeting you
NEW ORLEANS

Angie Lafmon

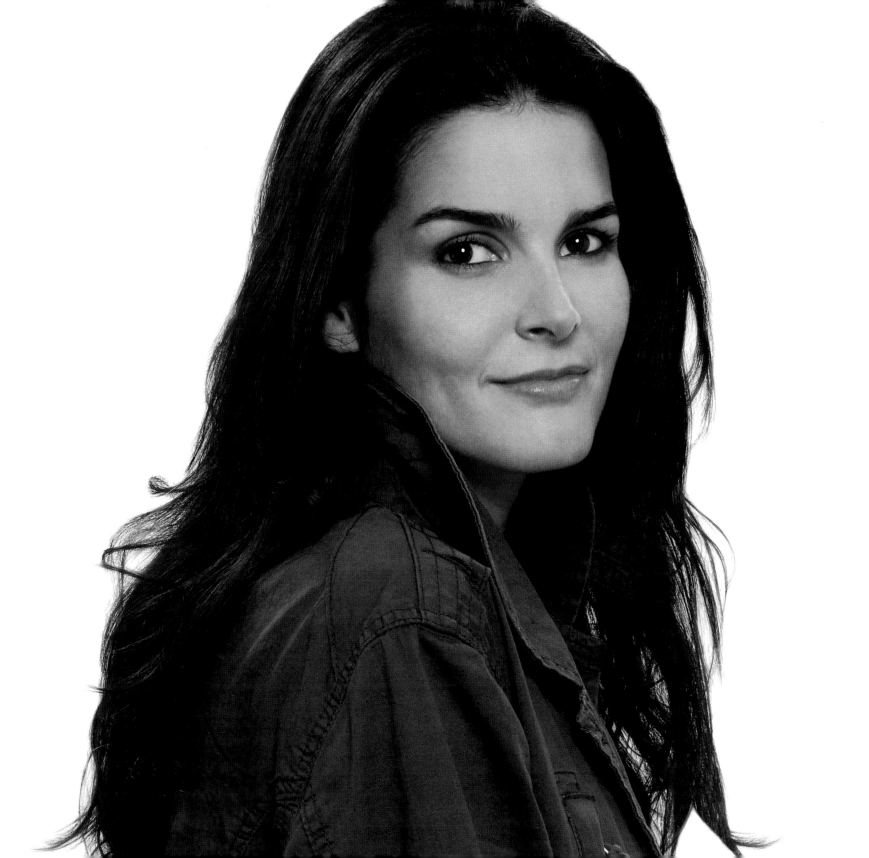

You've played the music
for us, now its time we play
the music for you...

♡ to you forever –

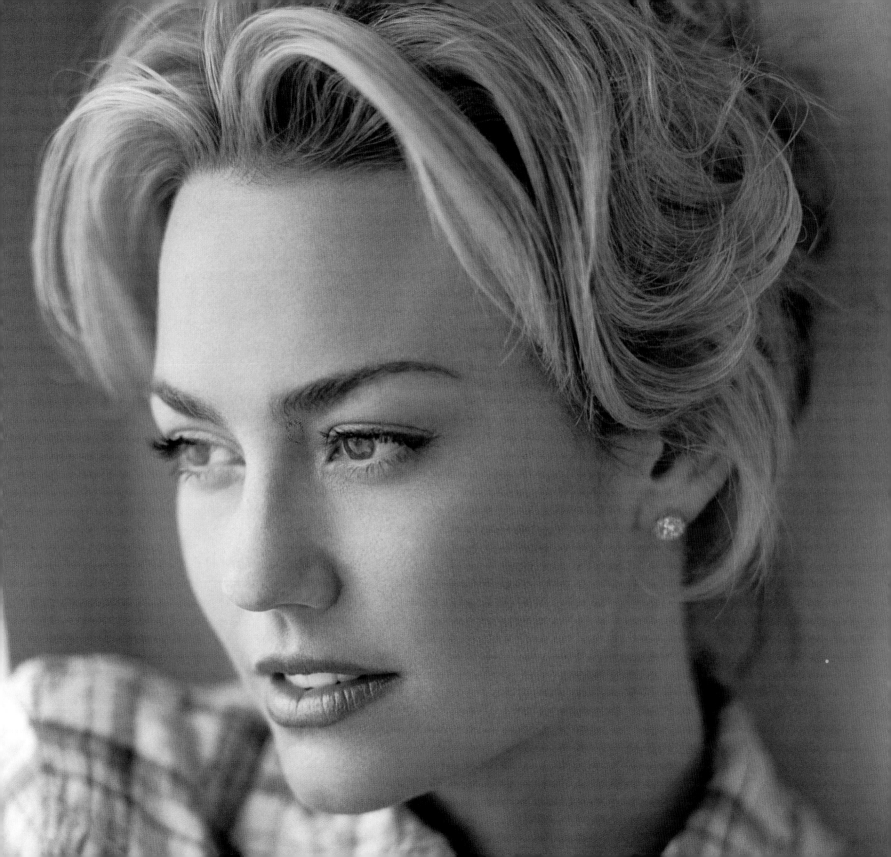

Keep the Faith - Help
is on the way, LATE, but coming
still.

In our prayers,

John Turturro

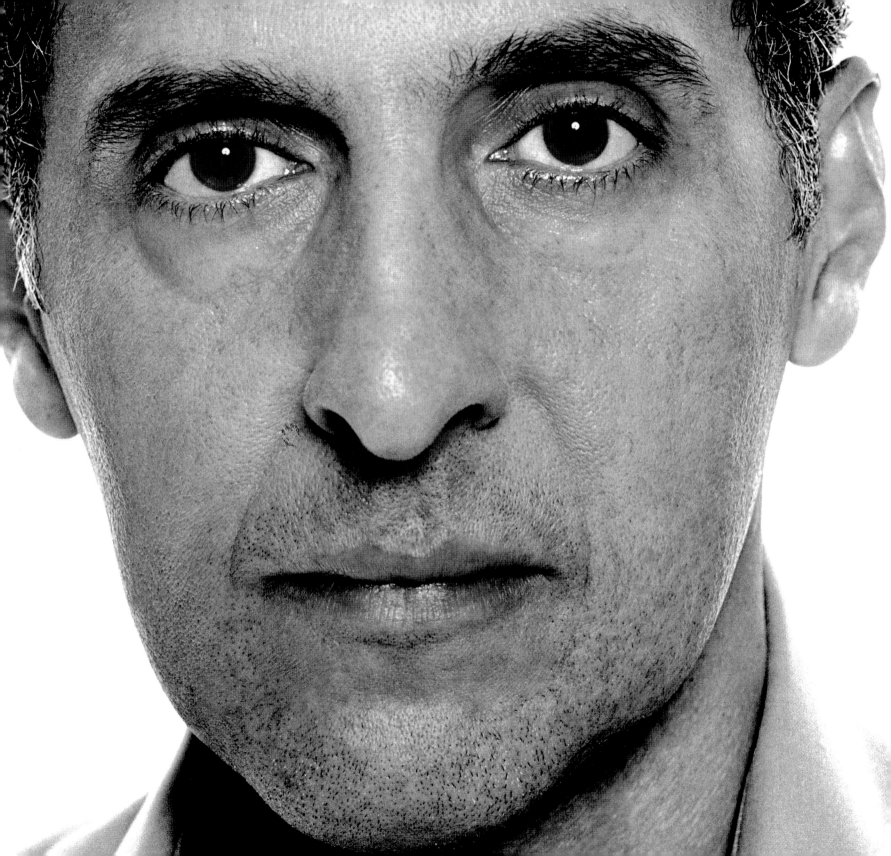

In the South

Strangers greet each other when they pass on the street

the highest compliment one can receive is you are
a good person

funerals are lively

and the tea is sweet

Di moin qui vous laimein,
ma di vous qui vous ye'

The above is an old creole proverb meaning

"Tell me whom you love and I'll tell you who you are"

whether to the south born or to the south drawn
the answer is the same

We are the South

with all my love,

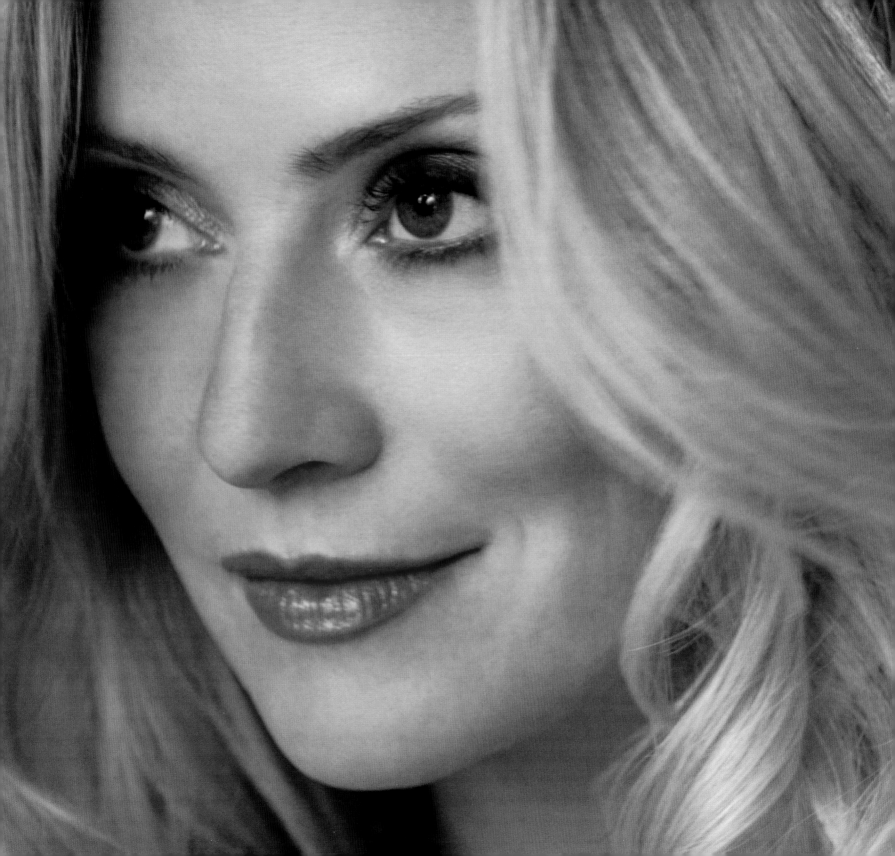

Everybody can be great... because anybody can serve. You don't have to have a college degree to serve. You don't have to make your subject and verb agree to serve. You only need a heart full of grace. A soul generated by love.
— Martin Luther King, Jr.

I can't begin to understand, to really know what you have lost. But I am beginning to know your courage. We all are. It is beautiful.

♡ Take heart.

Love.

Maggie Green

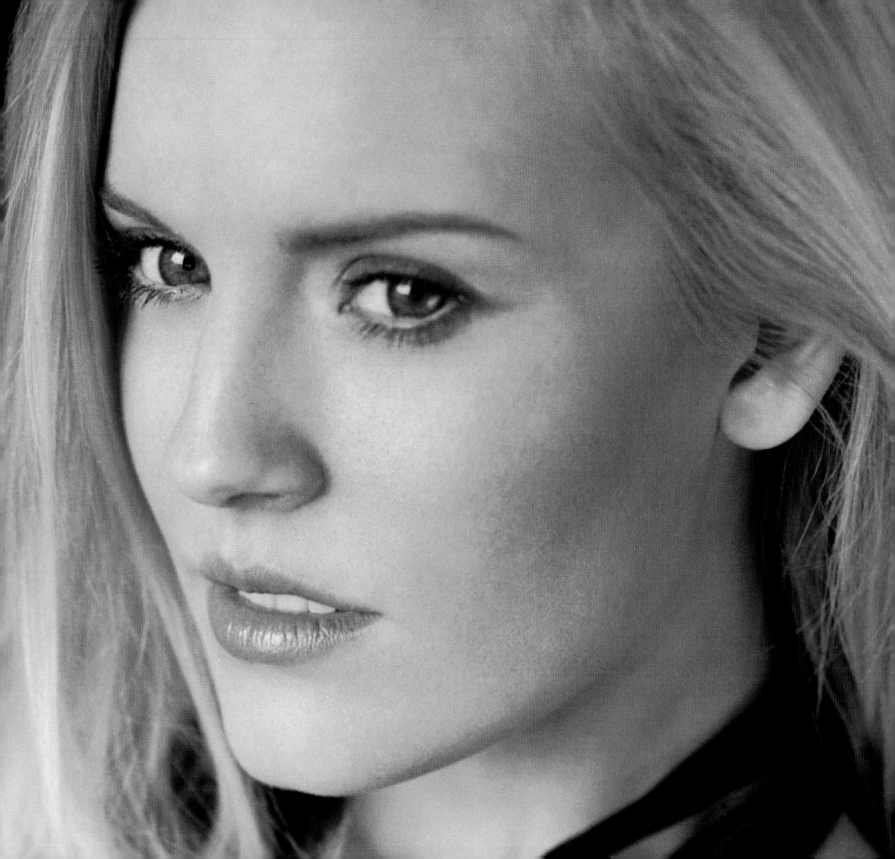

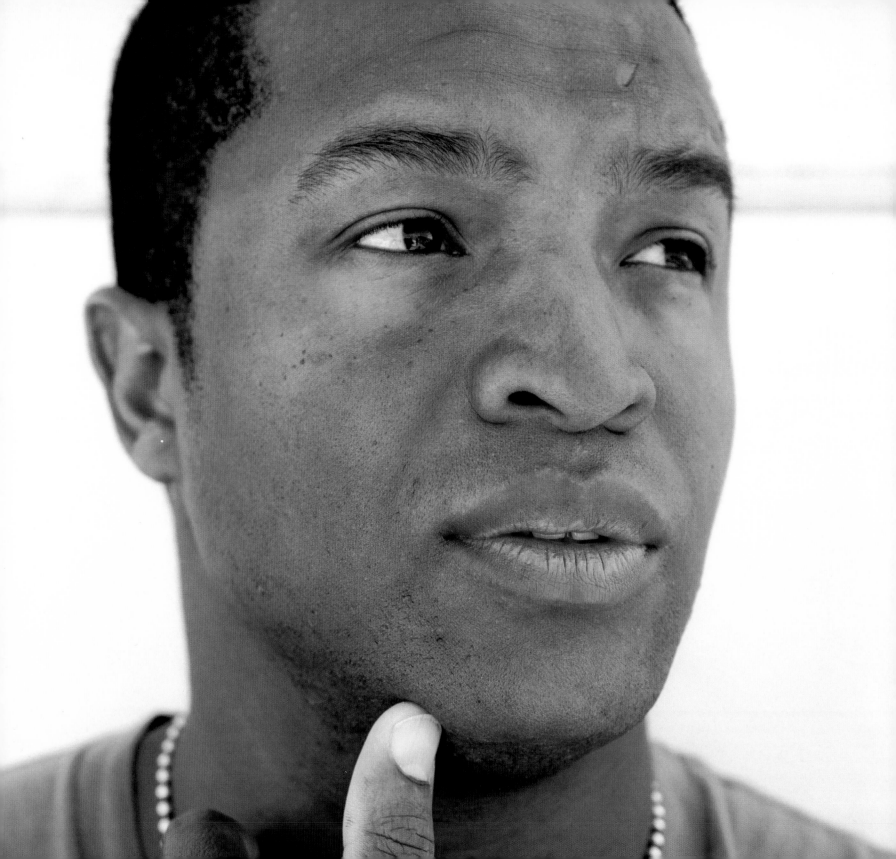

Let's keep moving forward together!

R. Cross

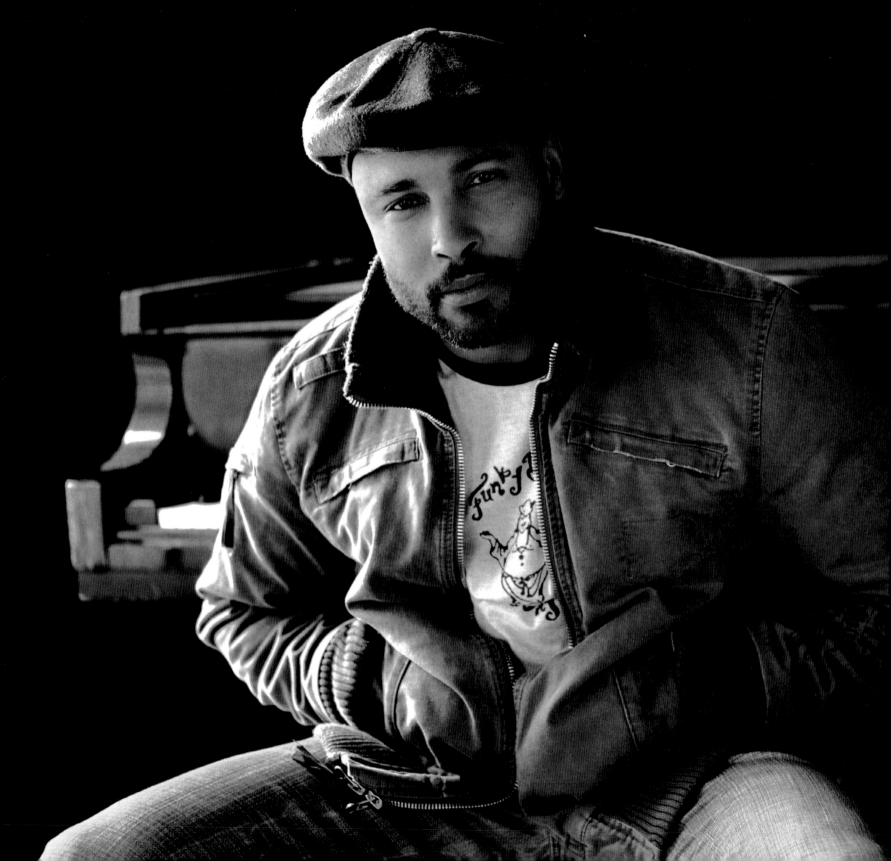

Hello my friends

Some may call you victims and fool
Sorry for you. But I call you Hero's
and thank god for you! I thank
Him for your courage, wisdom patience
and most of all for your love.
Kissing and smiling Hero's always
know that we love you more than you
could ever know. stay strong

Peace always

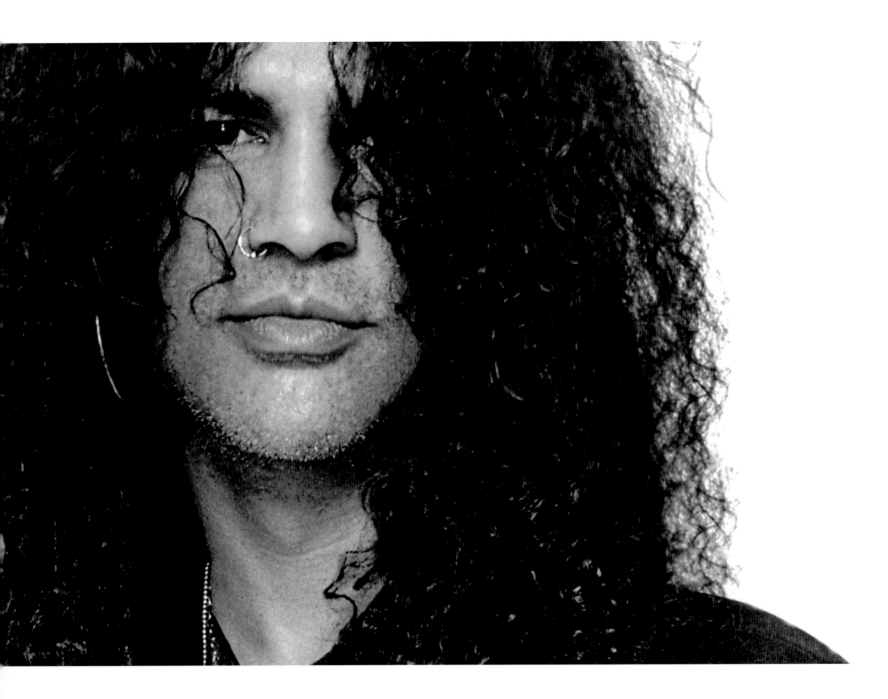

To All The People WHO Believe,
The Selfless & Tireless individuals
That Contribute wholeHeartedly To Restoring
Hope & Survival for those in NEED
Hats off Thats WHAT
This country is Really made of !

COLDPLAY send their Love
to NEW ORLEANS

CHRIS Jonny Guy Will

We hope you come back even better

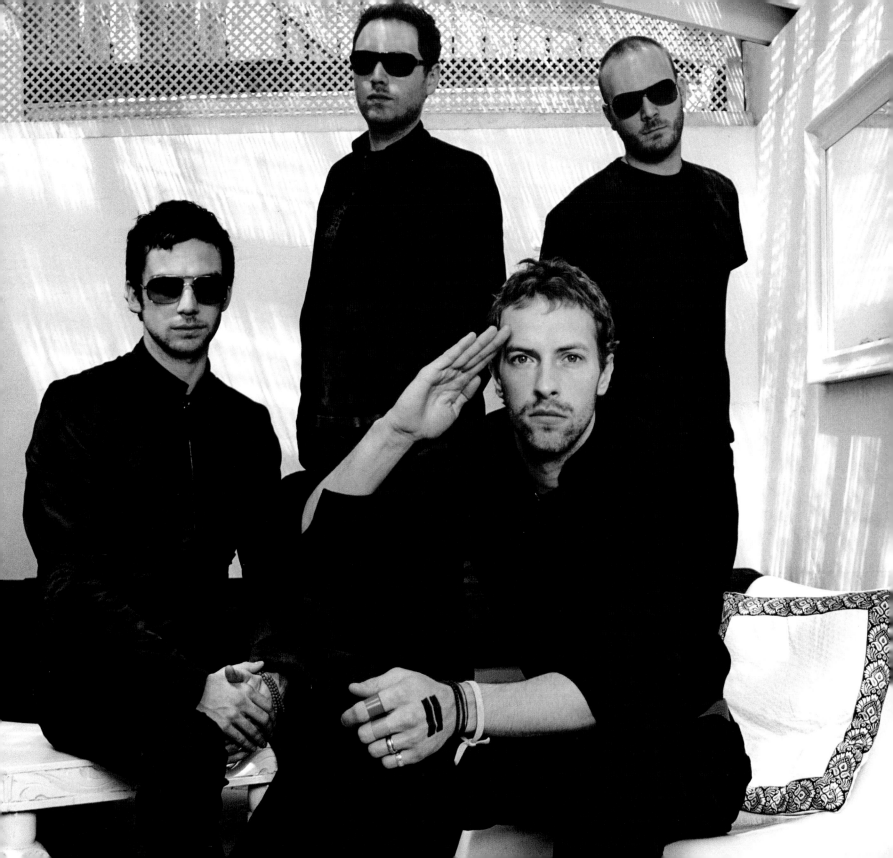

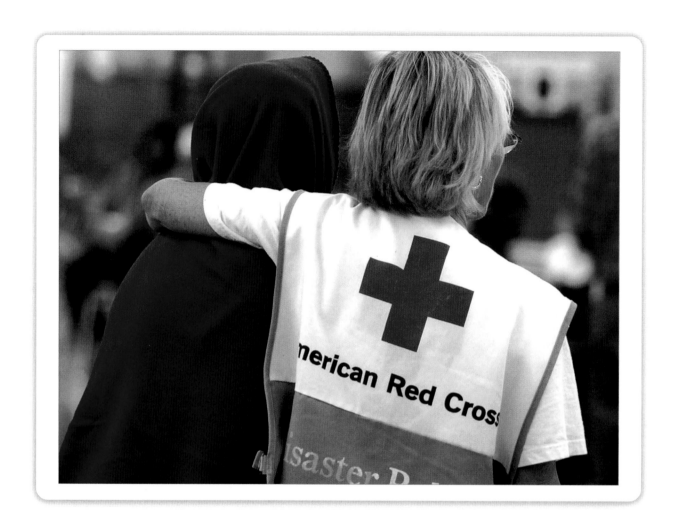

American Red Cross

As the howling winds and torrential rains of Hurricane Katrina sped through the Gulf of Mexico, dozens of trained American Red Cross disaster relief workers moved into action preparing – as they always do – to help people when they need it most. For 125 years, the Red Cross has been at the forefront, helping people prevent, prepare for and respond to emergencies. Whether the crisis is big or small, affects your neighborhood or spans the globe – the Red Cross is there at a moment's notice to provide immediate assistance. Hurricanes Katrina, Rita and Wilma, however, affected more people, over a larger area and to a more profound extent than any previous disaster, testing the organization as no disaster ever has before.

At the height of the relief effort, the Red Cross served more than 995,000 meals in one day, sheltered nearly 500,000 survivors and provided more than 1.4 million families with emergency financial assistance. All of this was made possible by the more than 200,000 volunteers who put their lives on hold for weeks – and even months – to help people whose lives were torn apart hurricanes Katrina, Rita and Wilma.

What was equally as remarkable was the overwhelming generosity of the American public – and people in communities throughout the world – who donated money to help people they had never even met. Some of the world's most well known companies made significant financial contributions and pushed their capacity to get supplies, equipment and services to relief sites. A collection of celebrities and other public personalities also contributed and encouraged people to donate. Many famous personalities also became involved in philanthropic projects – much like this one – to promote the good work of charitable organizations.

As long as the generosity, caring and willingness to extend a helping hand lives in the American heart, the Red Cross will turn that compassion into action. The Red Cross stands ready, relying on your support to meet the needs of people in your community – and throughout the world.

When a disaster strikes, the Red Cross responds immediately without regard for cost. Whether it's a house fire, a massive tornado, a hurricane or an earthquake, the Red Cross will be there bringing care and comfort to your neighbors across the street and across the country. In order to respond to disaster needs, whenever and wherever they arise, the Red Cross must have resources available in advance. For this reason, the Red Cross maintains a Disaster Relief Fund, so that it can deploy the necessary resources at a moment's notice.

With the purchase of this book, you're helping to ensure that the Red Cross can continue to meet today's needs – and the needs of tomorrow. For every book sold in the United States between now and September 30, 2007, AERIAL will donate $2.50 to the American Red Cross Disaster Relief Fund and $2.50 to Habitat for Humanity International Inc. The American Red Cross will receive a minimum donation of $25,000.

Because of you, the Red Cross is always there to help people when they need it most. When you help the American Red Cross, you help America. Find out more about the American Red Cross Disaster Relief Fund by visiting www.redcross.org.

With thousands upon thousands of houses destroyed, Habitat for Humanity launches "Operation Home Delivery" to assist in long-term rebuilding.

Habitat for Humanity®

Habitat for Humanity works in partnership with volunteers, donors and other nonprofit organizations to build simple, decent, affordable homes with low-income families around the globe. The public's response to Habitat's rebuilding efforts following hurricanes Katrina, Rita and Wilma was truly humbling. In the first few months after the hurricanes made landfall, thousands of generous donors contributed money and building materials to help with Habitat's work while others contributed, and continue to contribute, volunteer labor toward the rebuilding process.

With that help, Habitat for Humanity expects to build at least 1,000 houses by mid-summer 2007 through its "Operation Home Delivery" program. Still, with the devastation so great and so widespread, thousands of additional affordable homes will be needed. Habitat for Humanity will continue building with qualified, hurricane-affected families as long as resources allow. Frequently updated information about "Operation Home Delivery" progress can be found on the Habitat for Humanity website. **www.habitat.org**

CALL 1.800.HABITAT

credits

Photographs in order of appearance.

 Johnny Depp

Photographer: **Paul Alexander**
Windsor Arms Hotel, Toronto

 Colin Firth

Photographer: **Paul Alexander**
The Windsor Arms Hotel, Toronto
Grooming: Jane McKay, MAC

 Kristin Chenoweth

Photographer: **Paul Alexander**
The Roosevelt Hotel, Hollywood, CA
Hair: Garen Tolkin, Exclusive Artists
Make-up: Garen Tolkin, Exclusive Artists
Wardrobe: DKNY Jeans
Stylist: Cliff Hoppus, Exclusive Artists

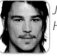 **Josh Hartnett**

Photographer: **Paul Alexander**
SOFITEL, New York City, NY
Grooming: Brian Campbell, MAC

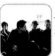 **Jared Leto & 30 Seconds to Mars**

Photographer: **Paul Alexander**
The Windsor Arms Hotel, Toronto
Grooming: Boriana Stoilkova, The Artist Group

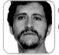 **Clifton Collins, Jr.**

Photographer: **Paul Alexander**
The Roosevelt Hotel, Hollywood, CA
Hair: Garen Tolkin, Exclusive Artists
Grooming: Garen Tolkin, Exclusive Artists
Stylist: Cliff Hoppus, Exclusive Artists

 Daisy Fuentes

Photographer: **Paul Alexander**
The Roosevelt Hotel, Hollywood, CA
Hair: Steven Lewis, Exclusive Artists
Make-up: Coleen Campbell-Olwell Exclusive Artists
Wardrobe: DKNY Jeans
Stylist: Cliff Hoppus, Exclusive Artists

 Claire Forlani

Photographer: **Nabil**
The Roosevelt Hotel, Hollywood, CA
Wardrobe: DKNY Jeans
Stylist: Cliff Hoppus, Exclusive Artists

 Justin Timberlake

Photographer: **Paul Alexander**
The Windsor Arms Hotel, Toronto
Grooming: Grace Lee, MAC

 Natasha Hentsridge

Photographer: **Paul Alexander**
The Roosevelt Hotel, Hollywood, CA
Hair: Steven Lewis, Exclusive Artists
Make-up: Coleen Campbell-Olwell, Exclusive Artists
Wardrobe: DKNY Jeans
Stylist: Cliff Hoppus, Exclusive Artists

 Alan Cumming

Photographer: **Paul Alexander**
The Windsor Arms Hotel, Toronto
Grooming: Boriana Stoilkova, The Artist Group

 Helena Bonham Carter

Photographer: **Paul Alexander**
The Windsor Arms Hotel, Toronto
Hair: Christian Mark
Make-up: Christian Mark

 Jimmy Smits

Photographer: **Paul Alexander**
Sofitel New York City, NY
Grooming: Brian Campbell, MAC

 Gabrielle Union

Photographer: **Paul Alexander**
The Roosevelt Hotel, Hollywood, CA
Hair: Kendra Beaudoin
Make-up: Motoko
Wardrobe: DKNY Jeans
Stylist: Cliff Hoppus, Exclusive Artists

 Ziggy Marley

Photographer: **Paul Alexander**
The Roosevelt Hotel, Hollywood, CA
Hair: Steven Lewis, Exclusive Artists
Grooming: Coleen Campbell-Olwell, Exclusive Artists
Wardrobe: DKNY Jeans
Stylist: Cliff Hoppus , Exclusive Artists

 Viggo Mortensen

Photographer: **Paul Alexander**
The Windsor Arms Hotel, Toronto

 Laura Breckenridge

Photographer: **Paul Alexander**
The Roosevelt Hotel, Hollywood, CA
Hair: Steve Mason, Exclusive Artists
Make-up: Shiyena Chun, Exclusive Artists
Wardrobe: DKNY Jeans
Stylist: Cliff Hoppus, Exclusive Artists

 Forrest Whitaker

Photographer: **Paul Alexander**
SOFITEL LA, Beverly Hills, CA
Grooming: Garen Tokin, Exclusive Artists

 Anthony LaPaglia & Gia Carides

Photographer: **Paul Alexander**
The Roosevelt Hotel, Hollywood, CA
Hair: Travis Marzalek, Exclusive Artists
Make-up and Grooming: Olaf Derlig, Exclusive Artists
Stylist: Cliff Hoppus, Exclusive Artists

 Lacey Chabert

Photographer: **Paul Alexander**
The Roosevelt Hotel, Hollywood, CA
Hair: Steven Lewis, Exclusive Artists
Make-up: Coleen Campbell-Olwell, Exclusive Artists
Wardrobe: DKNY Jeans
Stylist: Cliff Hoppus, Exclusive Artists

 DeRay Davis

Photographer: **Paul Alexander**
SOFITEL LA, Beverly Hills, CA
Grooming: Starr Sarkissian, Exclusive Artists
Wardrobe: DKNY Jeans

 Jon Bon Jovi

Photographer: **Paul Alexander**
SOFITEL, New York City, NY
Grooming: Philip Antonio, MAC

 Tom Arnold

Photographer: **Paul Alexander**
The Roosevelt Hotel, Hollywood, CA
Hair: Steven Lewis, Exclusive Artists
Grooming: Steven Lewis &
Coleen Campbell-Olwell, Exclusive Artists
Wardrobe: DKNY Jeans
Stylist: Cliff Hoppus, Exclusive Artists

 Anthony Mackie

Photographer: **Alison Dyer**
The Roosevelt Hotel, Hollywood, CA
Grooming: Steve Mason

David Banner

Photographer: **Paul Alexander**
SOFITEL LA, Beverly Hills, CA
Grooming: Starr Sarkissian, Exclusive Artists

Shawn Ashmore

Photographer: **Nabil**
The Roosevelt Hotel, Hollywood, CA
Hair: Daniel Erdmann, Exclusive Artists
Grooming: Kerry Malouf, Exclusive Artists
Wardrobe: DKNY Jeans
Stylist: Cliff Hoppus, Exclusive Artists

Adam Goldstein (DJ AM)

Photographer: **Nabil**
The Roosevelt Hotel, Hollywood, CA
Hair: Stephen Lewis, Exclusive Artists
Grooming: Miriam Vukovich
& Dana Pensiger, Exclusive Artists
Stylist: Cliff Hoppus, Exclusive Artists

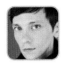

DJ Qualls

Photographer: **Nabil**
The Roosevelt Hotel, Hollywood, CA
Hair: Stephen Lewis, Exclusive Artists
Grooming: Miriam Vukovich
& Dana Pensiger, Exclusive Artists
Stylist: Cliff Hoppus, Exclusive Artists

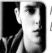

Penn Badgley

Photographer: **Nabil**
The Roosevelt Hotel, Hollywood, CA
Hair: Stephen Lewis, Exclusive Artists
Grooming: Miriam Vukovich
& Dana Pensiger, Exclusive Artists
Stylist: Cliff Hoppus, Exclusive Artists

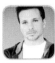

Drew Lachey

Photographer: **Nabil**
The Roosevelt Hotel, Hollywood, CA
Hair: Stephen Lewis, Exclusive Artists
Grooming: Miriam Vukovich
& Dana Pensiger, Exclusive Artists
Wardrobe: DKNY Jeans
Stylist: Cliff Hoppus, Exclusive Artists

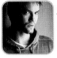

Shane West

Photographer: **Nabil**
The Roosevelt Hotel, Hollywood, CA
Hair: Steve Mason, Exclusive Artists
Grooming: Kim Verbeck, Exclusive Artists
Stylist: Cliff Hoppus, Exclusive Artists

Kate Walsh

Photographer: **Michael Grecco**
The Roosevelt Hotel, Hollywood, CA
Hair: Steve Mason, Exclusive Artists
Grooming: Kim Verbeck, Exclusive Artists
Stylist: Cliff Hoppus, Exclusive Artists

Melora Walters

Photographer: **Alison Dyer**
The Roosevelt Hotel, Hollywood, CA
Hair: Travis Marzalek, Exclusive Artists
Make-up: Olaf Derlig, Exclusive Artists
Wardrobe: DKNY Jeans
Stylist: Cliff Hoppus, Exclusive Artists

Ian Somerhalder

Photographer: **Alison Dyer**
The Roosevelt Hotel, Hollywood, CA
Hair: Travis Marzalek, Exclusive Artists
Grooming: Olaf Derlig, Exclusive Artists
Wardrobe: DKNY Jeans
Stylist: Cliff Hoppus, Exclusive Artists

Harry Hamlin & Lisa Rinna

Photographer: **Nabil**
The Roosevelt Hotel, Hollywood, CA
Hair: Stephen Lewis, Exclusive Artists
Make-up & Grooming: Kerry Malouf, Exclusive Artists
Wardrobe: DKNY Jeans
Stylist: Cliff Hoppus, Exclusive Artists

Regina Hall

Photographer: **Alison Dyer**
The Roosevelt Hotel, Hollywood, CA
Hair: Travis Marzalek, Exclusive Artists
Make-up: Olaf Derlig, Exclusive Artists
Stylist: Cliff Hoppus, Exclusive Artists

MELISSA GILBERT & DAKOTA BRINKMAN

Photographer: **Nabil**
The Roosevelt Hotel, Hollywood, CA
Hair: Jeffrey Paul, Exclusive Artists
Make-up: Jeffrey Paul, Exclusive Artists
Wardrobe: DKNY Jeans
Stylist: Cliff Hoppus, Exclusive Artists

Eric Balfour

Photographer: **Nabil**
The Roosevelt Hotel, Hollywood, CA
Hair: Stephen Lewis, Exclusive Artists
Make-up: Miriam Vukovich
& Dana Pensiger, Exclusive Artists
Stylist: Cliff Hoppus, Exclusive Artists

Dave Foley

Photographer: **Paul Alexander**
The Roosevelt Hotel, Hollywood, CA
Hair: Steve Mason, Exclusive Artists
Grooming: Shiyena Chun, Exclusive Artists
Wardrobe: DKNY Jeans
Stylist: Cliff Hoppus, Exclusive Artists

Susie Coehlo

Photographer: **Paul Alexander**
The Roosevelt Hotel, Hollywood, CA
Hair: Travis Marzalek, Exclusive Artists
Make-up: Olaf Derlig, Exclusive Artists
Wardrobe: DKNY Jeans
Stylist: Cliff Hoppus, Exclusive Artists

Rachel Blanchard

Photographer: **Paul Alexander**
The Roosevelt Hotel, Hollywood, CA
Hair: Steven Lewis, Exclusive Artists
Make-up: Coleen Campbell-Olwell, Exclusive Artists
Wardrobe: DKNY Jeans
Stylist: Cliff Hoppus , Exclusive Artists

Nicole Ari Kodjoe & Boris Kodjoe

Photographer: **Nabil**
The Roosevelt Hotel, Hollywood, CA
Hair: Stephen Lewis, Exclusive Artists
Make-up & Grooming: Kim Verbeck, Exclusive Artists
Stylist: Cliff Hoppus, Exclusive Artists

David Krumholtz

Photographer: **Paul Alexander**
The Roosevelt Hotel, Hollywood, CA
Hair: Garen Tolkin, Exclusive Artists
Grooming: Garen Tolkin, Exclusive Artists
Wardrobe: DKNY Jeans
Stylist: Cliff Hoppus, Exclusive Artists

Jonathan bennett

Photographer: **Alison Dyer**
The Roosevelt Hotel, Hollywood, CA
Hair: Steve Mason, Exclusive Artists
Grooming: Shiyena Chun, Exclusive Artists
Wardrobe: DKNY Jeans
Stylist: Cliff Hoppus, Exclusive Artists

Marshall Allman

Photographer: **Alison Dyer**
The Roosevelt Hotel, Hollywood, CA
Hair: Travis Marzalek, Exclusive Artists
Grooming: Olaf Derlig, Exclusive Artists
Wardrobe: DKNY Jeans
Stylist: Cliff Hoppus, Exclusive Artists

Lisa Edelstein

Photographer: **Alison Dyer**
The Roosevelt Hotel, Hollywood, CA
Hair: Jeffrey Paul, Exclusive Artists
Make-up: Jeffrey Paul, Exclusive Artists
Wardrobe: DKNY Jeans
Stylist: Cliff Hoppus, Exclusive Artists

Nicholas Gonzalez

Photographer: **Paul Alexander**
The Windsor Arms Hotel, Toronto
Grooming: Boriana Stoilkova, The Artist Group

Jessica Denay

Photographer: **Paul Alexander**
SOFITEL LA, Beverly Hills, CA
Hair: Starr Sarkissian, Exclusive Artists
Makeup: Starr Sarkissian, Exclusive Artists
Wardrobe: DKNY Jeans

Melissa Rivers

Photographer: **Paul Alexander**
The Roosevelt Hotel, Hollywood, CA
Hair: Steve Mason, Exclusive Artists
Make-up: Shiyena Chun, Exclusive Artists
Wardrobe: DKNY Jeans
Stylist: Cliff Hoppus, Exclusive Artists

Tom Cochrane

Photographer: **Paul Alexander**
The Windsor Arms Hotel, Toronto
Grooming: Boriana Stoilkova, The Artist Group

Dougray Scott

Photographer: **Alison Dyer**
The Roosevelt Hotel, Hollywood, CA
Hair: Travis Marzalek, Exclusive Artists
Grooming: Olaf Derlig, Exclusive Artists
Wardrobe: DKNY Jeans
Stylist: Cliff Hoppus, Exclusive Artists

Kelly Hu

Photographer: **Paul Alexander**
The Roosevelt Hotel, Hollywood, CA
Hair: Garen Tolkin, Exclusive Artists
Make-up: Garen Tolkin, Exclusive Artists
Wardrobe: DKNY Jeans
Stylist: Cliff Hoppus, Exclusive Artists

Johnathon Schaech

Photographer: **Paul Alexander**
The Windsor Arms Hotel, Toronto
Grooming: Tasleema Nigh, The Artist Group

Tony Okungbowa

Photographer: **Paul Alexander**
SOFITEL LA, Beverly Hills, CA
Grooming: Starr Sarkissian, Exclusive Artists

Michael Ealy

Photographer: **Paul Alexander**
The Roosevelt Hotel, Hollywood, CA
Hair: Steven Lewis, Exclusive Artists
Grooming: Coleen Campbell-Olwell, Exclusive Artists
Wardrobe: DKNY Jeans
Stylist: Cliff Hoppus, Exclusive Artists

JC Chasez

Photographer: **Nabil**
The Roosevelt Hotel, Hollywood, CA
Hair: Steve Mason for Exclusive Artists
Grooming: Kim Verbeck, Exclusive Artists
Wardrobe: DKNY Jeans
Stylist: Cliff Hoppus, Exclusive Artists

Annie Potts

Photographer: **Paul Alexander**
The Roosevelt Hotel, Hollywood, CA
Hair: Jeffrey Paul, Exclusive Artists
Make-up: Jeffrey Paul, Exclusive Artists
Wardrobe: DKNY Jeans
Stylist: Cliff Hoppus, Exclusive Artists

Kevin Bacon

Photographer: **Paul Alexander**
The Windsor Arms Hotel, Toronto, Canada
Grooming: Boriana Stoilkova, The Artist Group

Marlee Matlin

Photographer: **Nabil**
The Roosevelt Hotel, Hollywood, CA
Hair: Steve Mason, Exclusive Artists
Make-up: Kim Verbeck, Exclusive Artists
Wardrobe: DKNY Jeans
Stylist: Cliff Hoppus, Exclusive Artists

Robbie Robertson

Photographer: **Paul Alexander**
The Windsor Arms Hotel, Toronto

Jeremy Piven

Photographer: **Alison Dyer**
The Roosevelt Hotel, Hollywood, CA
Hair: Steve Mason, Exclusive Artists
Grooming: Shiyena Chun, Exclusive Artists
Stylist: Cliff Hoppus, Exclusive Artists

Jesse Metcalfe

Photographer: **Alison Dyer**
The Roosevelt Hotel, Hollywood, CA
Hair: Steve Mason, Exclusive Artists
Grooming: Shiyena Chun, Exclusive Artists
Wardrobe: DKNY Jeans
Stylist: Cliff Hoppus, Exclusive Artists

Angie Harmon

Photographer: **Paul Alexander**
SOFITEL LA, Beverly Hills, CA
Hair: Starr Sarkissian, Exclusive Artists
Makeup: Starr Sarkissian, Exclusive Artists
Wardrobe: DKNY Jeans
Stylist: Cliff Hoppus, Exclusive Artists

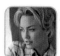

Kelly Carlson

Photograph: **Alison Dyer**
The Roosevelt Hotel, Hollywood, CA
Hair: Jeffrey Paul, Exclusive Artists
Make-up: Jeffrey Paul, Exclusive Artists
Stylist: Cliff Hoppus, Exclusive Artists

John Turturro

Photographer: **Paul Alexander**
The Windsor Arms Hotel, Toronto, Canada
Grooming: Grace Lee, MAC

Emily Procter

Photographer: **Paul Alexander**
The Roosevelt Hotel, Hollywood, CA
Hair: Steve Mason, Exclusive Artists
Make-up: Shiyena Chun, Exclusive Artists
Wardrobe: DKNY Jeans
Stylist: Cliff Hoppus, Exclusive Artists

Maggie Grace

Photographer: **Alison Dyer**
The Roosevelt Hotel, Hollywood, CA
Hair: Travis Marzalek, Exclusive Artists
Make-up: Olaf Derlig, Exclusive Artists
Stylist: Cliff Hoppus, Exclusive Artists

Roger Cross

Photographer: **Michael Grecco**
The Roosevelt Hotel, Hollywood, CA
Hair: Steve Mason, Exclusive Artists
Grooming: Kim Verbeck, Exclusive Artists
Stylist: Cliff Hoppus, Exclusive Artists

Matthew St. Patrick

Photographer: **Paul Alexander**
The Roosevelt Hotel, Hollywood, CA
Hair: Travis Marzalek, Exclusive Artists
Grooming: Olaf Derlig, Exclusive Artists
Wardrobe: DKNY Jeans
Stylist: Cliff Hoppus, Exclusive Artists

SLASH

Photograph: **Paul Alexander**
The Rogers Centre, Toronto
Producer: Deb Belinsky

COLDPLAY

Photograph: **Paul Alexander**
Amber Lounge, Toronto
Producer: Vivian Vassos
Grooming: Shelley Lashley
Stylist: Adrienne Shoom

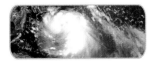

August 27, 2005, marked the first day that an eye became apparent in satellite imagery of Hurricane Katrina. NASA's Terra satellite captured this image at 11:20 a.m. U.S. Central time, the inner eyewall had begun to deteriorate and an outer eyewall was forming. The two eyewalls are clearly visible as two concentric circles at the center of the storm. Katrina was also expanding, and by the end of the day, had doubled in size.

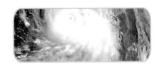

Katrina exploded into a Category 5 hurricane with winds of 257 kilometers per hour (160 miles per hour). When Katrina came ashore on August 29, it was one of the deadliest and costliest storms to hit the United States. Hurricane Katrina (12L) approaching the Gulf Coast

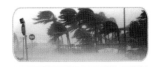

HURRICANE KATRINA HITS FLORIDA
A Fort Lauderdale parking lot is blasted by blowing sand and rain as Hurricane Katrina makes landfall along the southeast coast of Florida on August 25, 2005. The Category 1 hurricane produced wind gusts over 80 miles per hour.

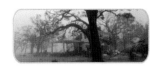

Hurricane Katrina blasts through the beachfront area of Gulfport, Mississippi on August 29, 2005.

Sentiments of residents show on the wall of a bakery and deli in Buras, La., Monday, Oct. 10, 2005. Buras and surrounding areas were hardest hit by Hurricane Katrina. (AP Photo/Don Ryan)

Dec. 24, 2005. The tradition of burning dozens of massive bonfires, believed by local children to illuminate the river so Papa Noel, the south Louisiana Santa Claus, can find their homes, took place Christmas Eve despite Hurricane Katrina's impact in the area. (AP Photo/Jacqueline Larma)

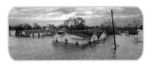

NEW ORLEANS - AUGUST 29: Water comes up to the roof of homes after Hurricane Katrina came through the area with high winds and water on August 29, 2005 in New Orleans, Louisiana. Katrina was down graded to a category 4 storm as it approached New Orleans. (Photo by Chris Graythen/Getty Images)

A housing complex is strewn with rubble from other buildings as well as it's on near the beach in Gulfport, Miss, Wednesday, Aug. 31, 2005. The buildings were destroyed as Hurricane Katrina passed through the area last Monday morning. (AP Photo/Phil Coale)

An apartment complex damaged by Hurricane Katrina is shown in this aerial view Wednesday, Aug. 31, 2005 in Long Beach, Miss. (AP Photo/David J. Phillip

The First Baptist Church of Gulfport sits in ruins on Beach Boulevard Friday morning, Sept. 2, 2005.

I family struggles Habitat For Humanity

Joey Stevens, of Lewisville, takes a moment to pray before bedding down for the night on the floor at Air Base Baptist Church in Alexandria, Louisiana. The group stopped here for the night before continuing to Slidell, Louisiana. Park Lake Baptist Church members and others convoy from Sachse, Texas to Slidell, Louisiana to help bring relief to victims of Hurricane Katrina.

Destroyed Mississippi Gulf Coast Highway I-90 as a result of winds and tidal surge from Hurrican Katrina. Pass Christian, Missipi, October 4, 2005 -illinoisphoto.com enhanced fema photo- Destroyed Mississippi gulf coast Highway I-90 as a result of winds and tidal surge from Hurrican Katrina. This section of bridge connect Pass Christian, near Gulfport to Bay St. Louis. 16kd965katrinaI90

A volunteer hammers a nail into the wall of a house in the efforts to help rebuild after the destruction off Hurricane Katrina. (Habitat for Humanity)

American Red Cross volunteer Maurrie Sussman, right, comforts a New Orleans resident, who asked not to be identified, in the dining area of the Veterans Memorial Coliseum in Phoenix Tuesday, Sept. 6, 2005. More than 500 residents from the New Orleans areawere evacuated to Phoenix Sunday because of Hurricane Katrina. (AP Photo/Tom Hood)

 paul alexander

PAUL ALEXANDER - Paul Alexander's extraordinary photographs have been featured on numerous album covers, magazines and global advertising campaigns. His recent exhibition entitled One Night Stand opened to critical acclaim in Toronto. Paul's uncanny ability to instantly connect with his subjects gives him insights into their personalities, and it is with the utmost precision that he applies that knowledge to his magnificent photographs.

 pixelcarve inc

PIXELCARVE - Pixelcarve's proven results in web development, digital video, print & graphic design, corporate identity and 3d animation have established the company as one of Toronto's premiere design firms. www.pixelcarve.com

Snudge Bros. - A highly sought after and dynamic collective of award-winning creative artists, Snudge Bros. specialize in brand development, creative strategy and execution, art direction, television and motion picture direction, advertising, marketing and communication.

THE WINDSOR ARMS HOTEL – Toronto's most prestigious and luxurious boutique hotel, The Windsor Arms Hotel fuses history and new-millennium amenities to create a delicate balance of old-world charm and modern decadence.

 artistgrouplimited.com

THE ARTIST GROUP Representing Canada's top creative talent, the Artist Group provides hair stylists, makeup artists, fashion and direction styling, prop and set décor. With over 50 artists under its management, it is one of Canada's most respected creative agencies.

 AERIAL COMMUNICATIONS GROUP

Aerial - A notable departure from traditional public relations agencies. Dynamic, creative and highly focused, the Aerial team provides senior, hands-on service and ventures beyond traditional public relations boundaries to deliver strategic communications programs that yield bottom line results.

 meta4media meta4media.com

Meta 4 Media- Formed by a group of talented individuals tired of the corporate paper shuffle, Meta4Media is a web design firm focused simply on making great websites.

 MAKE-UP PROVIDED BY M·A·C

MAC - MAC Artist Relations actively liaises with the world's film, television, music and theatrical industries. The MAC PRO Team, comprises MAC's stable of senior make up artists, is the voice, spirit, and living embodiment of MAC products and culture. In the world's creative centers, members of the MAC PROTeam can be found on-set at photo shoots, backstage at the international fashion shows, behind the scenes at award nights, creating the onscreen looks for top celebrities or supplying techniques and tips to the world's media.

BLUR PHOTO - Blur Photo represents some of America's most prolific photographers and provides editorial, advertising, publicity, full production support and all related needs. Thank you to Clio Bitboul, Alison Dyer, Nabil, Michael Grecco, Michael Lohr, Peter Breza, Shane O'Donnell, Douglas McMahon and Justin Officer.

www.iconla.com

The Icon – The Icon has grown from a conventional photo lab to the premiere imaging destination in Los Angeles. Building on more than twenty years of photography experience, The Icon has honed a highly customized approach to film processing that allows for greater versatility in the way all jobs are handled.

Exclusive Artists – Representing hair stylists, makeup artists, wardrobe stylists, prop stylists, manicurists and models , Exclusive Artists Management is one of North America's foremost management companies. Its artists work with a wide variety of talent on everything from magazine covers to high profile red carpet events.

Capture Digital – Capture digital offer photographers a wide range of the latest digital camera system rental packages along with experienced and well trained technicians. Capture digital collaborates with photographers through every phase of their digital experience including digital post production and capture through to final file output.

A THOMPSON HOTEL

Roosevelt Hotel - Since 1927 the Roosevelt has been the playground of luminaries including Clark Gable, Carole Lombard and Marilyn Monroe and the birthplace of the Academy Awards. Sweeping renovations by acclaimed designer Dodd Mitchell in 2005 heralded its rebirth -- a place where old Hollywood and young Hollywood entwine.

SOFITEL LOS ANGELES

Sofitel LA – Sofitel Los Angeles, an Accor hotel, boasts 295 newly-renovated guest rooms, many with views of the legendary Hollywood sign. The hotel, which enjoyed a complete $40 million renovation in 2006 features celebrity chef Kerry Simon's first Los Angeles location, SIMON LA and STONE ROSE Lounge, the newest Hollywood hotspot from Rande Gerber. The hotel is also home to a full service, luxury spa - LeSpa at Sofitel -a first by Sofitel in the United States. Sofitel Los Angeles also offers one of the city's largest hotel fitness centers – SO Fit and 10,000 square feet of meeting space with catering by SIMON LA, an outdoor heated swimming pool, high-speed and Wi-Fi Internet, 24-hour SIMON LA room service and more. www.sofitel.com

Calumet is committed to offering the very best selection of reliable photographic equipment and accessories available in the world. Its vast inventory includes a full range of popular camera, lighting, digital and grip equipment from the industry's top manufacturers.

SOFITEL NEW YORK

The 398-room Sofitel New York is located at 45 W. 44th Street between 5th and 6th Avenues, within walking distance of New York's most desirable destinations. The hotel offers gourmet French cuisine at Gaby restaurant, a fitness center, seven meeting rooms, a grand ballroom and Wi-Fi Internet access throughout the hotel. Sofitel's spacious guestrooms have marble baths and Sofitel's exclusive and ultra-luxurious bedding system consisting of a plush feather comforter, feather bed and four over-sized feather pillows. www.sofitel.com.

SUN
STUDIOS / EQUIPMENT / DIGITAL
www.sunnyc.com

Sun Studios is renowned for beautiful daylight, exceptional amenities and the latest camera, lighting and digital equipment. It was through their generous support that we were able to capture the images created in New York. Special thanks to Darbin, Daniele, James and Dan Wetuk for the support and contribution in the undertaking of our project. We can't thank you enough.

MAKE-UP PROVIDED BY

MAC Artist Relations actively liaises with the world's film, television, music and theatrical industries. The MAC PRO Team, comprises MAC's stable of senior make up artists, is the voice, spirit, and living embodiment of MAC products and culture. In the world's creative centers, members of the MAC PRO Team can be found on-set at photo shoots, backstage at the international fashion shows, behind the scenes at award nights, creating the onscreen looks for top celebrities or supplying techniques and tips to the world's media. Special thanks to Patrick Eichler.

DKNY JEANS

"Love can heal wounds, rebuild buildings, and create hope. Our strength, passion, and sheer determination empowers us to make a difference. We're all connected and together we can do anything." Donna Karan

DKNY Jeans is proud to provide wardrobe for the many humanitarians who were photographed for this extraordinary book. All the clothing used during the shoots in New York and Los Angeles will be donated for use by those less fortunate. We at DKNY Jeans hope that all those affected by the disastrous 2005 hurricane season will find strength and comfort in the support of those who will continue to assist.

"IT IS BETTER TO LIGHT A CANDLE
THAN TO CURSE THE DARKNESS."

IT IS MY HOPE THAT THE DARK
AND DIFFICULT PATH TO RECONSTRUCTION
IS LIT WITH A MILLION CANDLES.

LOVE

JACKIE CHAN
06.